IMAGES
of America

CHESTER COUNTY
MUSHROOM FARMING

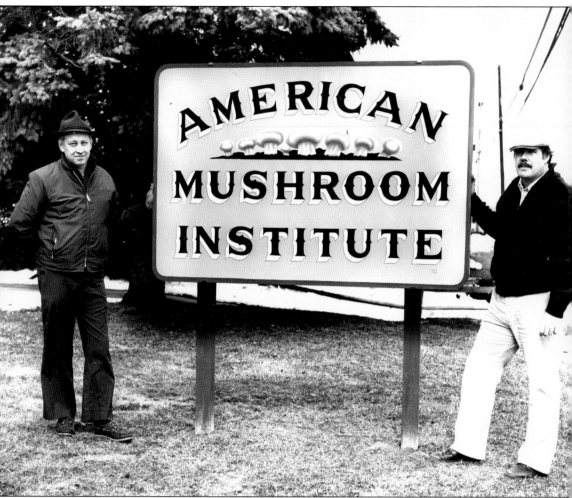

The idea for the American Mushroom Institute (AMI) began prior to America's involvement in World War II by growers in Chester County. The growers wanted an organization to act as an advocate for the mushroom farm community. After World War II, the growers resumed efforts to organize, and the AMI was founded in January 1955. On the right is Henry Roberts, president of the AMI in 1976 and 1977.

On the cover: The cover image is of a Pennsylvania State University researcher studying shiitake mushrooms. Pennsylvania State University and the mushroom industry have joined forces over the years to study mushrooms and make the growing process more efficient. (Courtesy of the American Mushroom Institute.)

IMAGES
of America

CHESTER COUNTY MUSHROOM FARMING

Bruce Edward Mowday

ARCADIA
PUBLISHING

Published by Arcadia Publishing
Charleston SC, Chicago IL, Portsmouth NH, San Francisco CA

Printed in the United States of America

Library of Congress Catalog Card Number: 2007942120

For all general information contact Arcadia Publishing at:
Telephone 843-853-2070
Fax 843-853-0044
E-mail sales@arcadiapublishing.com
For customer service and orders:
Toll-Free 1-888-313-2665

Visit us on the Internet at www.arcadiapublishing.com

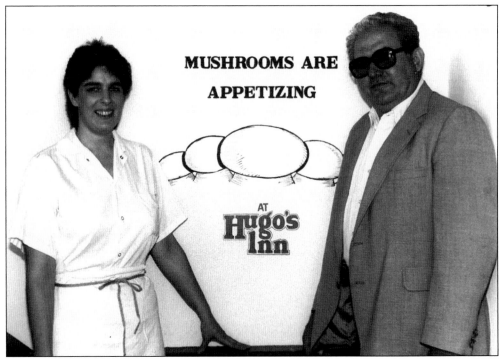

Mushrooms are a healthy and delicious food source. For years Hugo's Inn, just outside of Kennett Square near Longwood Gardens, specialized in mushroom dishes. Close to the inn was also the Phillips's mushroom museum. Both the inn and museum are no longer in existence. Bob Maucher, former owner of the inn, is shown.

CONTENTS

ACKNOWLEDGMENTS

The members of the American Mushroom Institute (AMI) and the organization's Community Awareness Committee deserve credit for the production of this book on mushroom farming in Chester County. All of the images from this book are from the files of the AMI and the Community Awareness Committee.

A special thank-you goes to Sara Manning, who is in charge of the organization's office in Avondale. Sara shared her knowledge of the AMI and allowed me access to the file drawers full of wonderful historic images. She was generous with her time to review the copy.

The Community Awareness Committee members also fully backed this project. The committee's chairman is Don Needham, and the members are Christopher Alonzo, James Angelucci, Tom Brosius, Edward Leo, Buster Needham, Gene Richard, Peter Alonzo, Tyler McKinney, Michael Hopkins, Scott McIntyre, Michael Pia, Brent Stinson, and James Yeatman.

Discussions for this book began in the Mushroom Cap in Kennett Square. Kennett Square is known as the Mushroom Capital of the World. Kathi Lafferty, store owner, opened this store in 2004 on all things mushroom and added a mini mushroom museum. Lafferty is festival coordinator of the Kennett Square Mushroom Festival.

Taking part in the discussions at the Mushroom Cap were Sara Manning and Mark Lorentz, an excellent photographer who does many photographs for the members of the Community Awareness Committee. The preliminary discussions also included longtime growers Charlie Brosius and Ed Leo. They both offered encouragement for the book. Brosius, his wife Jane Brosius, and Leo also offered their time to review the information for the book. Jim Angelucci, Sara Manning, and other members of the Community Awareness Committee also reviewed the draft of this book.

Katherine Harlan, my wife, contributed to this publication. She is an excellent copy editor and has excellent creative and marketing ideas. Good friends also contributed information for this book. Wendy Walker, a writer and journalist, answered questions on community issues. Nannette Morrison, a Charlottesville, Virginia, author, offered a book on mushrooms for my use.

The fine staff at Arcadia, especially junior publisher Erin L. Vosgien, has been great to work with on this book and my others for Arcadia. Those books are *Along the Brandywine River*, *Coatesville*, *Downingtown*, and *West Chester*.

I thank everyone who has aided in this production, especially the many photographers who contributed to the AMI photographic collection.

—Bruce Edward Mowday
February 2008

INTRODUCTION

Historians have noted the existence of mushrooms for many centuries. In ancient civilizations mushrooms were utilized as a medicine and not as a food source. Not until French chefs in the 17th century began using mushrooms in exotic dishes did the mushrooms become a flavorful and nutritious addition to the diets of many people. Today a variety of mushrooms are grown throughout the world and enjoyed in an array of dishes.

While many countries of the world grow mushrooms and most culinary cultures make use of them, the center of the mushroom universe in the United States is Chester County, Pennsylvania. The area around Kennett Square is proudly known as the Mushroom Capital of the World. There are more mushroom-growing operations concentrated in southern Chester County than any other area in the United States.

In the United States, mushroom growing began after the Civil War as growers from the Kennett Square area started cultivating mushrooms as a seasonal crop. As advancements were made in the science of growing mushrooms, farmers were able to have longer growing periods. Mushroom farming grew in Pennsylvania and Chester County to a year-round endeavor as scientific advances were made. Today mushroom farming is a major component of the commonwealth of Pennsylvania's leading industry, agriculture.

The Community Awareness Committee of the AMI has traced the roots of mushroom farming in Chester County. The committee has written, "The specialty, which was to make Chester County world-renowned, began about 1885, when William Swayne, a successful florist in Kennett Square, conceived the idea of growing mushrooms beneath his greenhouse benches. He sent to England for spawn, and the results were sufficiently encouraging to make him decide that a separate building would make it possible to control the growing conditions for mushroom culture. He built the first mushroom house in the area, and his son, J. Bancroft Swayne, returning from college, took over the mushroom business and made it a commercial success, eventually developing a spawn plant and a cannery in addition to the growing houses. Encouraged by the Swayne success and the attractive price of mushrooms in city markets, others began the production of mushrooms as their principal occupation."

The idea for the AMI began prior to America's involvement in World War II by growers in Chester County. The growers wanted an organization to act as an advocate for the mushroom farm community. Efforts to organize the AMI were suspended during the war. After World War II, the growers resumed efforts to organize the mushroom farmers, and in the 1950s, Walter L. Gmuer of F. D. Croce and Company, Inc., of New York City took a leadership role and became the first executive director of the AMI.

Louis Toto of Landenberg spearheaded a membership drive of local mushroom growers in 1954, the same year that 100 mushroom owners agreed to work together to advertise mushrooms. With the help of attorney George J. Brutscher, the organization was incorporated and bylaws were developed and the AMI was legally incorporated on January 14, 1955.

In 1955, as it is today, the AMI's purpose was to promote increased consumption of cultivated mushrooms by every means possible, including research, advertising, publicity, merchandising, consumer education, and government relations. The organization also assists in the developing of better and more economical methods of growing, packaging, and shipping mushrooms.

The AMI works with mushroom farmers and suppliers and with educational institutions, including Pennsylvania State University, for the betterment of the mushroom growers. The AMI is a national voluntary trade association representing the growers, processors, and marketers of cultivated mushrooms in the United States and industry suppliers worldwide.

Mushroom farming in Chester County over the past century and has seen varied ethnic groups take part in the industry. Quaker and Irish growers began mushroom farming, and later Italian and Latino families joined to work in the industry and eventually own their own farms. Chester County mushroom farms have become an economic force. Mushroom farms supply many jobs to the community, and mushroom farming also supports many other industries.

The photographs in this book showcase the history of mushroom growing in Chester County. Many of the photographs depict growing methods that no longer are used in today's modern mushroom industry.

Members of the Community Awareness Committee also contribute in many ways to the community. They are active members of local governments and civic organizations. They also support educational endeavors. Each year the committee holds a golf tournament to raise money for college scholarships for local students. Deserving students apply for the scholarships and write essays about the mushroom industry. Some of the proceeds of this book will go to those scholarships.

The yearly Kennett Square Mushroom Festival in Kennett Square is held in September, National Mushroom Month as declared by the United States Department of Agriculture. More than 100,000 visitors come from far and wide to experience the festival. The Mushroom Festival is a volunteer organization whose proceeds are distributed to a wide variety of charities and organizations benefitting the residents of Kennett Square and the surrounding communities.

Mushroom farmers are also mindful of the environment and take every precaution to protect the land. Advancements in technology have also helped mushroom farmers to become more efficient and less intrusive on their neighbors. To compete in today's worldwide market, mushroom farmers must continue to look for innovative and cost-effective ways to grow, package, and sell mushrooms.

The growers can certainly look to the mushroom pioneers for inspiration. William Swayne began the industry in Chester County. Others from the county diversified from the standard white button mushroom to more exotic mushrooms, such as crimini, portabella, maitake, shiitake, enoki, and oyster.

After more than a century, mushroom farming in Chester County continues to evolve.

One

MUSHROOM GROWING

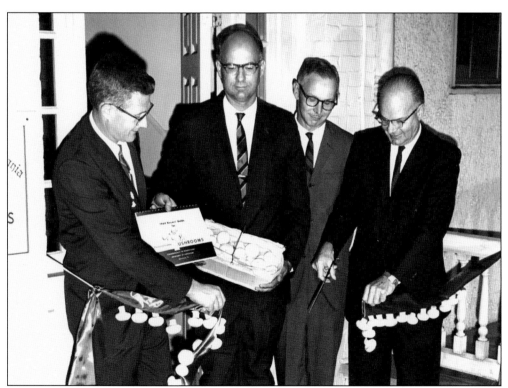

One of the main goals of the American Mushroom Institute (AMI) is to promote the sale of mushrooms. For decades the AMI has had national campaigns and September has been designated National Mushroom Month. This photograph shows the kickoff of the 1964 mushroom campaign. Note the mushrooms that are attached to the ribbon being cut to begin the campaign. In the photograph from left to right are John M. Gibson, AMI president; Benjamin Reynolds, president of the Southeastern Chamber of Commerce of Kennett Square; Kennett Square mayor F. Tworzydlo; and Pennsylvania secretary of agriculture Leland Bull.

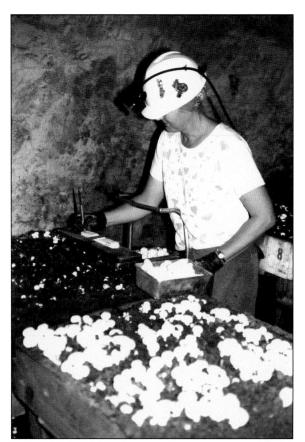

The mushroom-growing process takes place in many segments. The mushrooms are constantly watched to make sure they are healthy and to determine when they are to be picked. In the photograph at left, a researcher is weighing and counting mushrooms. The process is time consuming and in some cases done every day. In the photograph below, workers are checking the mushroom beds.

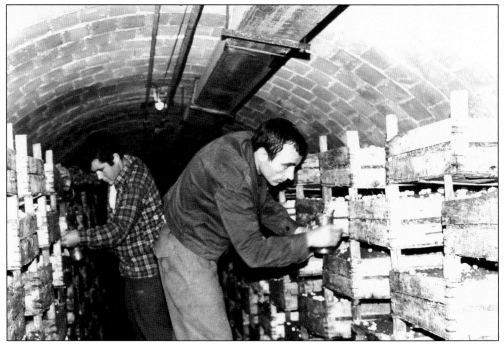

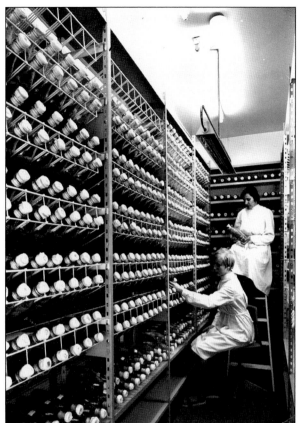

Before the mushroom-growing process begins, spawn needs to be grown and injected into the growing beds. The photograph at right shows one of the spawn-growing rooms. The photograph below is of Dr. Lee Schisler, a Pennsylvania State University professor emeritus of plant pathology. He is an internationally renowned researcher who devoted his career to helping the mushroom industry. He was named Outstanding Alumnus of the College of Agricultural Sciences for 2007.

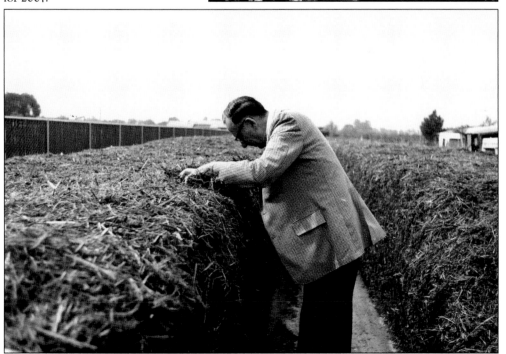

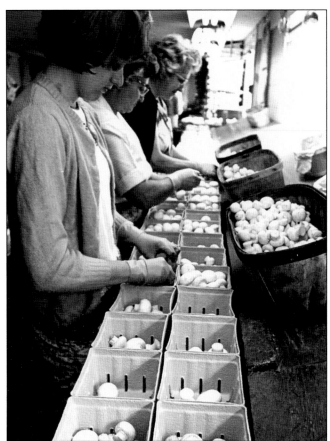

Packaging is an important component of the mushroom business. Mushrooms need to be as fresh as possible when delivered to retailers and used by the consumer. The full flavor and healthy nutrients are found in fresh mushrooms. In the photograph at left, women are sorting through white button mushrooms, while in the photograph below, workers are using modern equipment to help with the packaging.

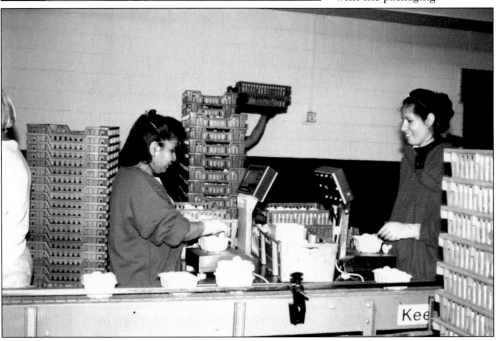

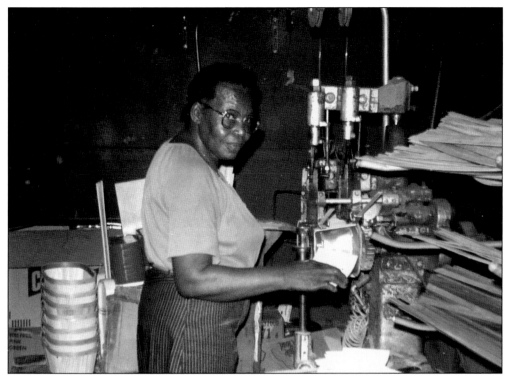

Part of the packing process involves the placing of the plastic wrap over the packages destined for national distribution. The packaging is regulated by national standards, and the mushroom growers closely follow all of the governmental guidelines for the growing, handling, and packaging of mushrooms. In the photograph above, a worker packs mushrooms in a three-pound basket, while in the photograph below, a machine applies the plastic wrap.

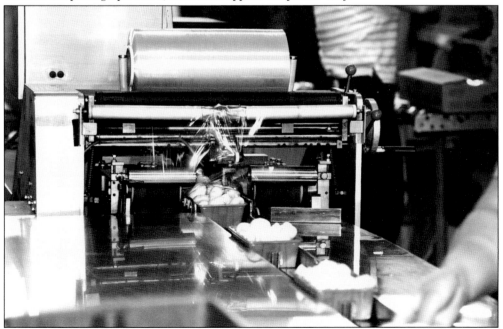

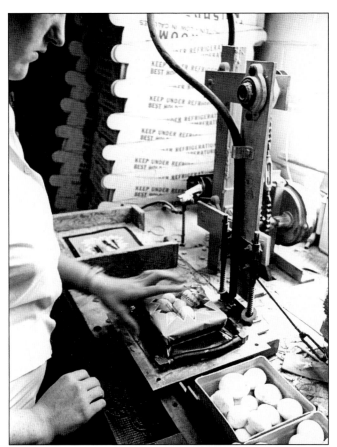

Climate control is an important part of the mushroom-growing process. Mushrooms can be adversely affected by improper growing conditions. Temperature and other circumstances are closely monitored to make sure the crop is healthy and at its peak when picked. In the photograph below, a worker is checking growing conditions, while in the left-hand photograph, a worker is weighing and packaging mushrooms.

The mushroom industry has been thriving in Chester County for more than a century. The growing process has advanced over the years, including the machinery that is used to help growers in all stages of the development. Shown in the photograph at right is the John C. Leo farm in Avondale as seen in 1962. In the photograph below, a tractor loader is premixing materials.

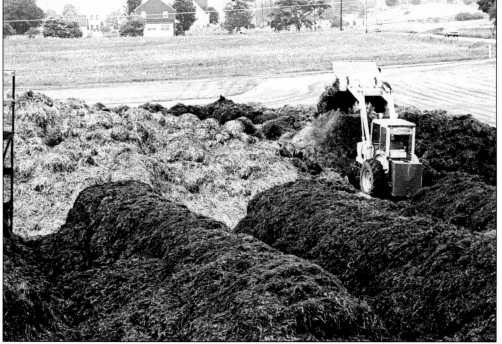

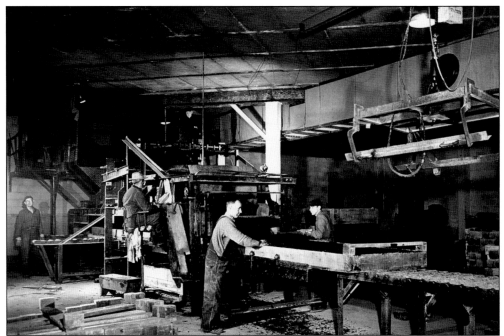

Mushroom growers and workers know their profession requires hard work and long hours. In the photograph above, a conveyor line is being readied to sort and begin the packing process. In the photograph below, tractor loaders are being utilized as the workers spray water on the compost pile, a part of the process. In the background is a growing room.

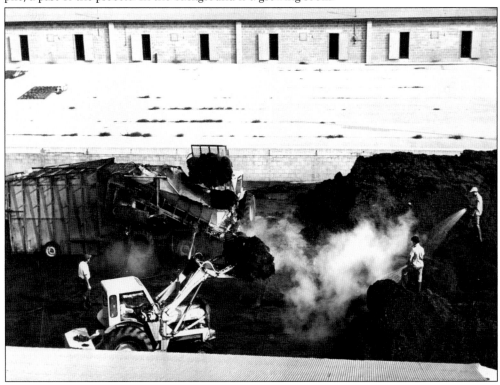

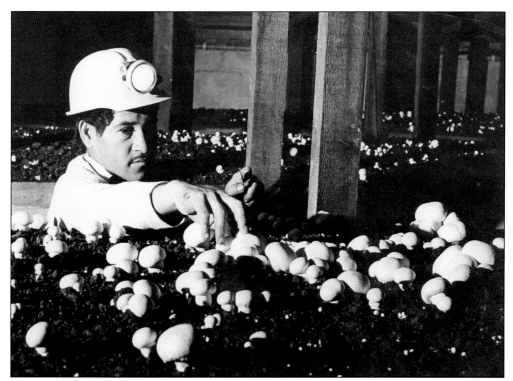

Growing conditions are strictly controlled in the mushroom-growing houses. Light, temperature, and other factors are closely monitored every day. In the two photographs on this page mushroom workers don lighted helmets so they are able to examine the mushrooms to see if they are growing properly and ready to pick.

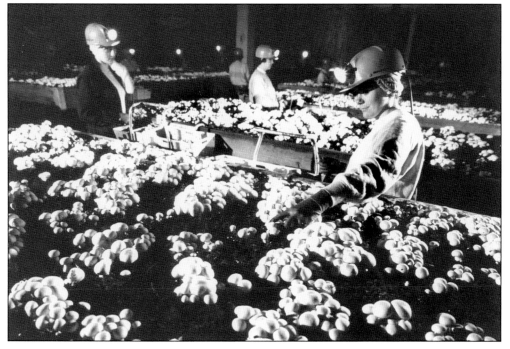

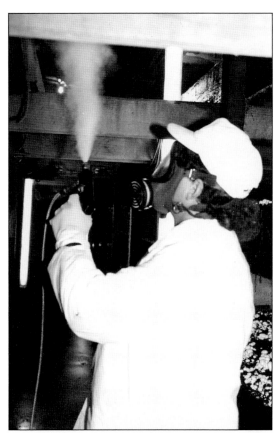

Great care is given to making sure the growing rooms are clean and germ free. Mushroom farms make sure all federal standards of cleanliness are met. In the photograph at left, watering is conducted by one of the workers. In the photograph below, Winnie Hewins is packaging three-pound boxes of fresh mushrooms at the Ponderosa Mushroom farm in an undated photograph.

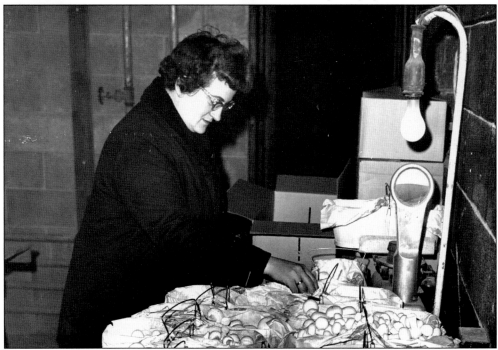

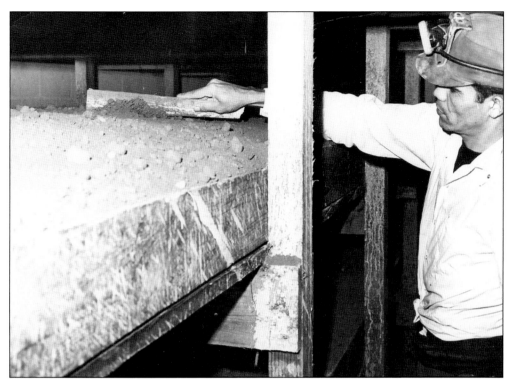

The growing bed has to be properly prepared to begin the growing of the mushrooms. In the photograph above, one of the mushroom-house employees is leveling off the casing soil to attain an even bed depth. The picking of the mushrooms is labor intensive. In the photograph below, another worker is checking to see if the mushrooms are ready to be picked.

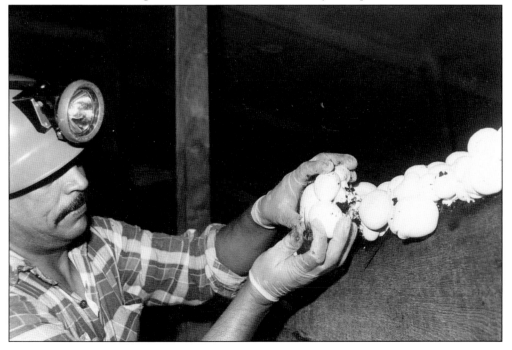

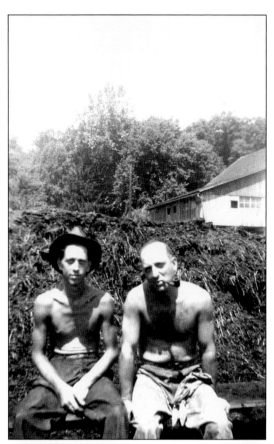

The Leo family has been one of the leading Chester County mushroom-growing families for many years. In the photograph at left, two members are seen taking a break from work. The photograph was taken before World War II. In the photograph below are members of three of the four mushroom-growing generations of Leo family members. From left to right, they are Dan, John, and Ed Leo.

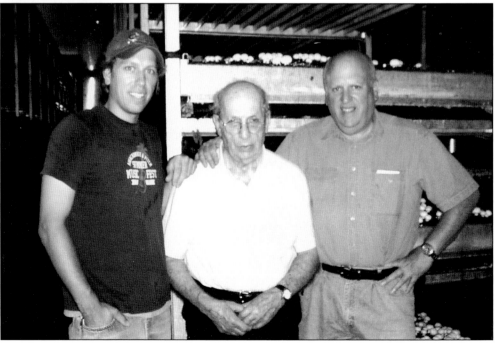

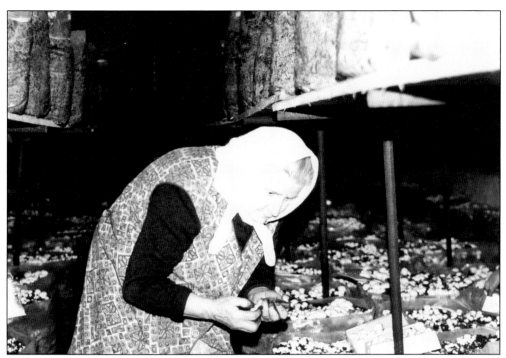

One of the keys to the success of mushroom operations is picking the mushrooms at the proper time and shipping them fresh to the customers. The picking of the mushrooms is not an easy job, as demonstrated by the woman in the photograph above. The woman in the photograph below is handling a box of picked mushrooms. The next stop for the mushrooms will be the packaging station. The photographs are from European operations.

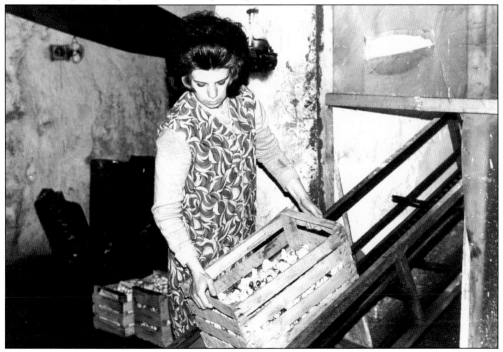

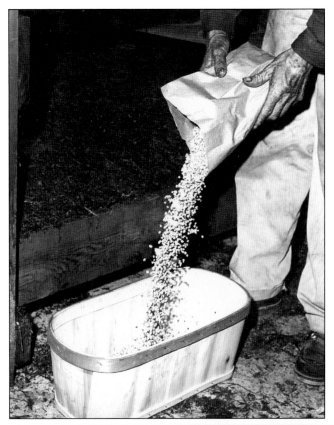

The growing process for mushrooms is much different from most crops. Mushrooms need low temperatures and are cultivated indoors, unlike most crops. Since mushrooms do not contain chlorophyll, they need to be fed. The photograph at left depicts a portion of the spawning process. The photograph below has workers checking the progress of the growing cycle in Europe.

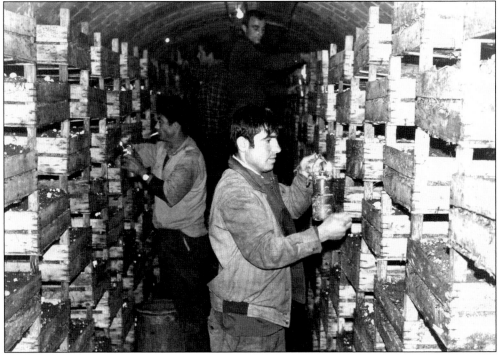

The two photographs on this page deal with the distribution of the sterile dirt used for casing. The photograph at right has workers filling the boxes, and the photograph below has a worker doing a rough leveling of the casing material after the dirt has first been dumped. All mushrooms need compost to grow. The compost needs sufficient nutrients for the mushrooms to thrive but not so much that unwanted organisms will grow too.

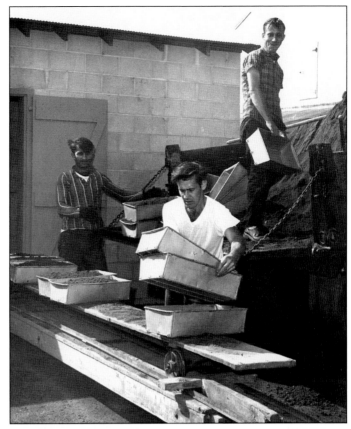

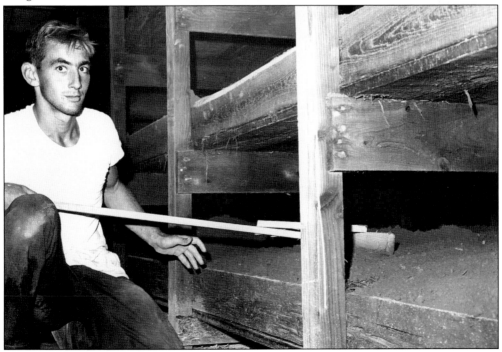

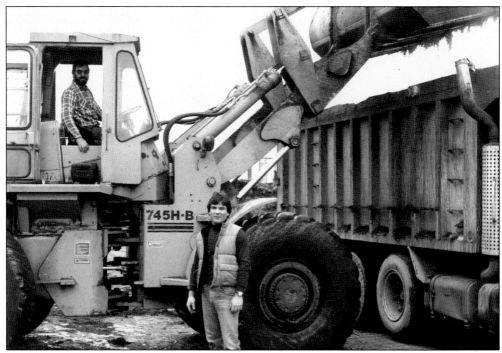

The first phase of making compost is the mixing of raw ingredients. Adequate moisture, oxygen, nitrogen, and carbohydrates are needed. During this phase the compost must be turned to aerate the compost heap. The photographs on this page depict work on the compost. Notice the two men on top of the heap spraying water and raking in the photograph below. Shown are Tom Lafferty (right) and his brother, Steve, in the photograph above.

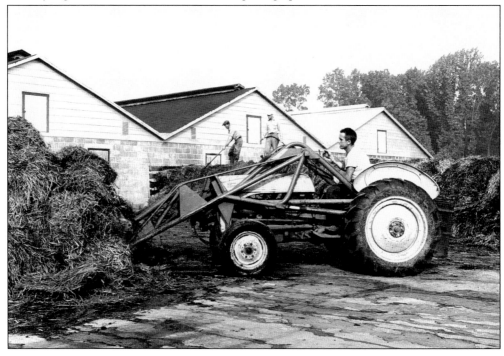

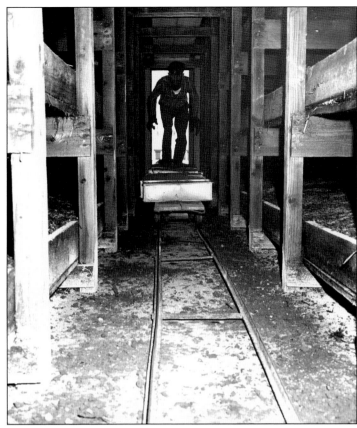

The mixing of the compost pile is usually done outdoors, but sometimes it is done under a covered roof. The mix is moved to a concrete slab near the end of a mushroom house prior to being transferred to the beds. In the photograph at right, a worker is bringing casing soil into the house via a mini railroad. The photograph below shows two workers bottling spawn prior to its growing period.

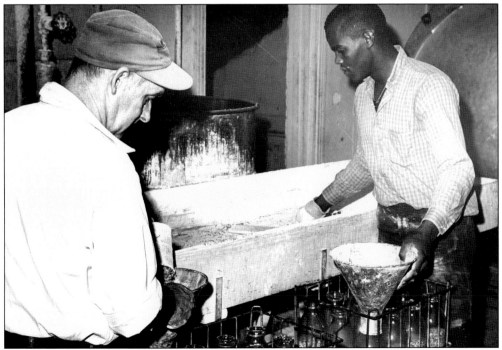

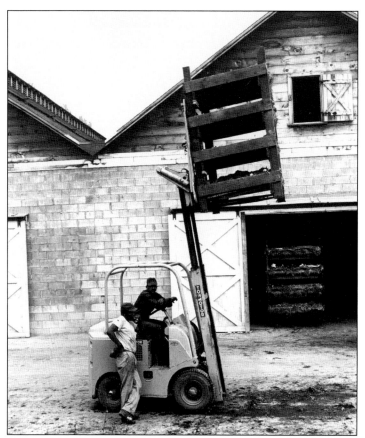

All aspects of the mushroom farms have been updated in the last half century. The two photographs on this page were taken on September 27, 1960, and show the wooden trays being readied for planting and then being moved by a forklift into the mushroom houses. The construction of the trays has advanced and made the growing process easier on the workers and more efficient.

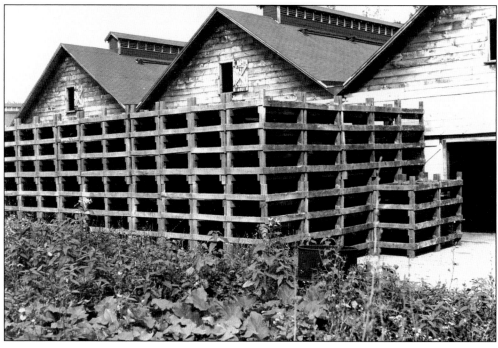

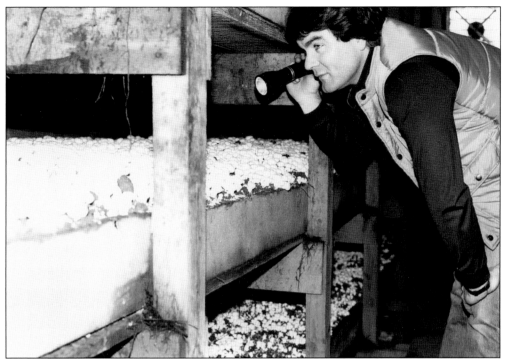

After the mushroom bed is filled with compost and leveled, the room is ready to be sealed and the temperature raised by injecting steam into the room. The steam helps to purify the room and to get rid of unwanted organisms. The process can take from a week to two weeks. In the two photographs on this page, workers are inspecting the mushrooms as they grow. In the photograph above is Tom Lafferty.

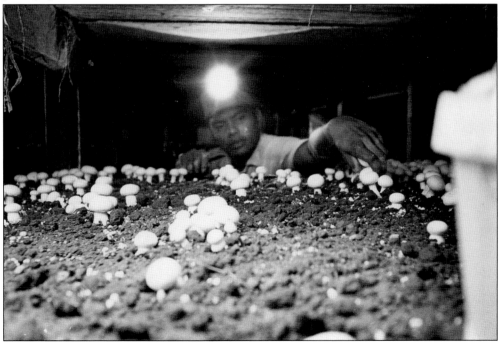

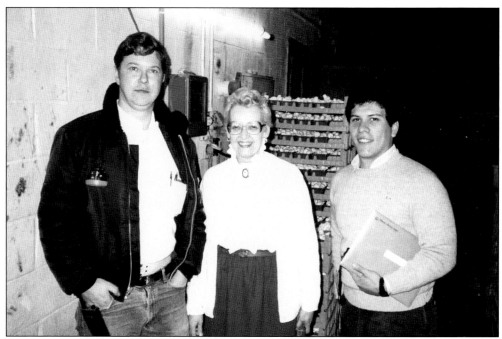

Once the compost has been prepared, the temperature of the houses must be lowered to between 75 and 80 degrees. The next step in the growing process is the introduction of spawn to the compost. The photograph below shows the packing of spawn prior to shipping to farms. The photograph above was taken at Kaolin Farms and shows Ann Hagarty with two of the workers.

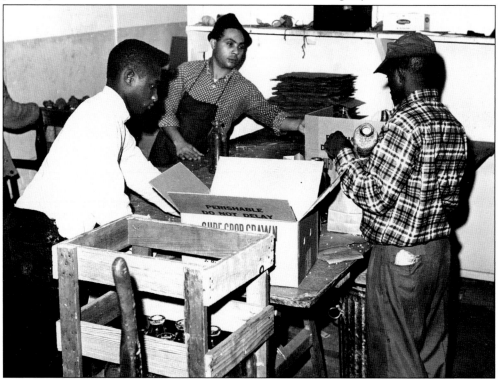

The first mushrooms ready to be picked appear within three weeks. The harvesting periods occur in cycles with a few days in between when mushrooms are picked. The picking takes place as long as mushrooms appear and at least three cycles are normal. The photographs on this page show how some of the work used to be done in sorting picked mushrooms. The photograph below is from a cannery operation. The photograph at right shows Guy Cordivano.

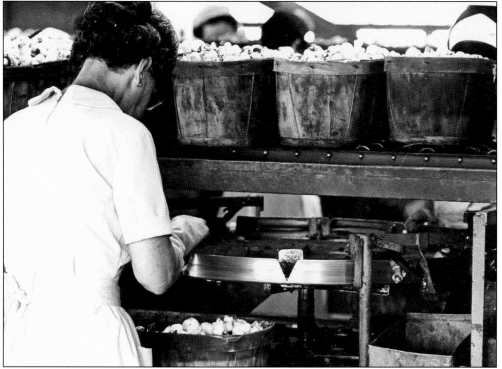

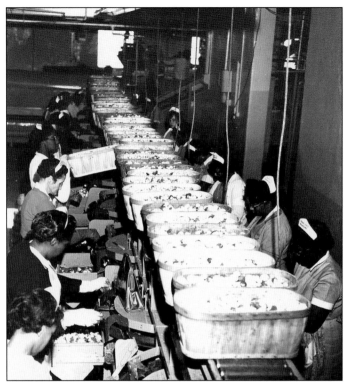

The addition of machinery has helped make the packaging of mushrooms easier for workers. The machines also speed up the process. In the photograph at left, mushrooms are lined up and ready for the cutting machines where stems are trimmed. In the photograph below, glass jars begin their trip on the canning line where they are filled with processed mushrooms.

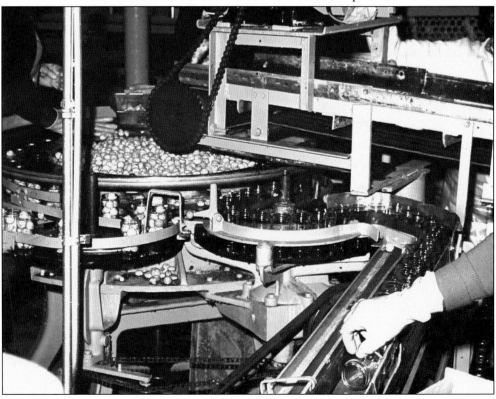

The casing allows the mycelium to produce fruiting bodies, mushrooms. The casing is an important part of the growing process. The mushrooms appear in the top layer of soil. In the photograph at right, mushroom workers are picking the fully grown mushrooms. In the photograph below, a worker is demonstrating his skill during one of the Kennett Square Mushroom Festivals, held each year in September.

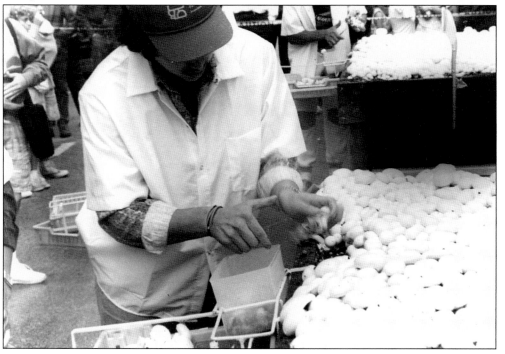

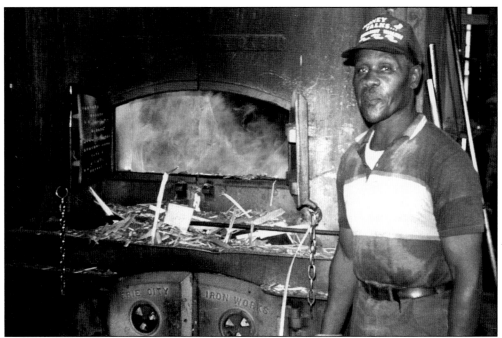

A growing cycle, from the preparation to the cleaning of the mushroom house after picking, can take as much as 13 weeks. Thus the mushroom farm can go through about four growing cycles a year. The quality of the mushrooms depends on many elements, including environmental conditions, the spawn, and casing. In the photograph above, a mushroom worker is raising the temperature of a growing house, and in the photograph below, mushrooms are being graded in a cannery operation.

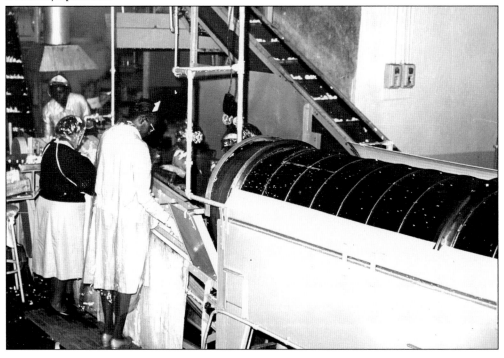

Two

AMERICAN MUSHROOM INSTITUTE

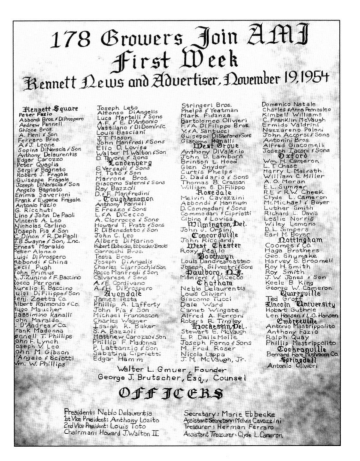

On the wall of the AMI's office in Avondale is a plaque dedicated to the 178 growers that joined the AMI during its first week of existence. A photograph of this plaque is shown on this page. The names were displayed in the *Kennett News and Advertiser* on December 19, 1954. The founder was Walter L. Gmuer, and counsel to the organization was George J. Brutscher of Kennett Square. Neblo Delaurentis was the first president.

Members of the AMI and the organization's Community Awareness Committee take every opportunity to promote mushrooms and give out samples. In the photograph above, grower Charlie Brosius, at right, is displaying mushrooms during Pennsylvania Food Products Month with Richard Grubb, Pennsylvania secretary of agriculture. In the photograph below, mushroom name tags are used at a different event. At left is Walter Gmuer, then executive director of the AMI. Gmuer served from 1956 until 1967. Third from left is Neblo Delaurentis, the first president of the AMI.

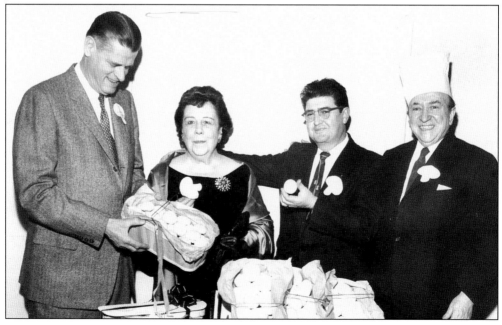

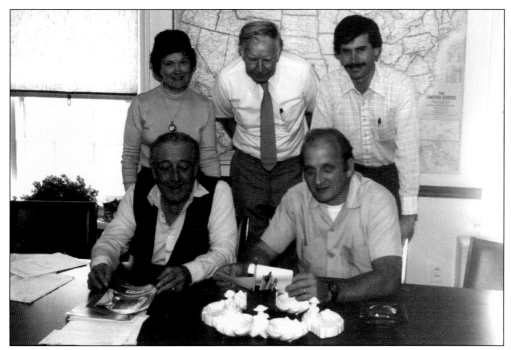

The backbone of any successful organization is its staff. The AMI and the Community Awareness Committee have had many great professionals working at their offices. Notice the mushroom carvings on the desk in the photograph above. Shown from left to right are (first row) Melvin Cavazzini and Steve Kimmell; (second row) Alma Rigler, Charlie Harris, and Gary Schroeder. In the photograph below is Tim King, public relations director for the AMI for a number of years and also executive director from 1975 until 1979. The mushroom plaque on the wall is used as a display for many events.

Mushrooms are grown all over the world, and other countries have their own promotional organizations. In the photograph at left is Denis Locke, who was director of the Mushroom Growers' Association, London, and member of its publicity committee. The photograph below shows one of Chester County's mushroom ambassadors, Charlie Ciarrocchi of Modern Mushrooms. Ciarrocchi was president of the AMI during 1977 and 1978.

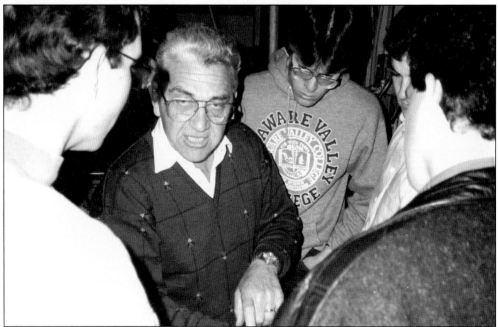

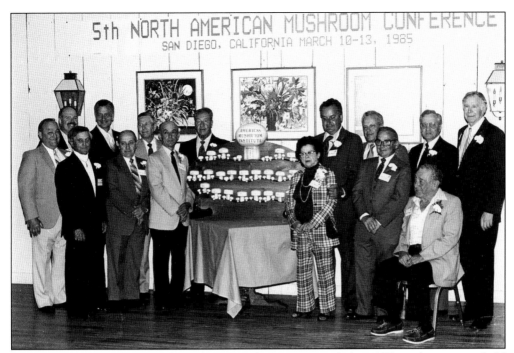

The AMI hosts conferences throughout North America, and the 1985 conference was held in San Diego, California. The photograph above shows members of the AMI along with the mushroom plaque that usually rests in the AMI offices in Chester County. The photograph below shows part of the celebration of National Mushroom Week held in November 1957. Mushroom Queen Gretchen Dahm presented mushrooms to Reading mayor Daniel McDevitt. In the center is Rocky Colavito, a major-league baseball player with the Cleveland Indians.

Two of the leaders of the AMI are shown on this page. In the photograph at left is Harold Parrish, who was president of the AMI in 1967 and 1968. The photograph below shows Walter W. Maule, general manager of the Mushroom Growers' Association of Kennett Square. He retired after 35 years and was presented a plaque in recognition of his many years of service and innumerable contributions to the mushroom industry. The presentation was made on June 12, 1958, at a luncheon in Wilmington, Delaware.

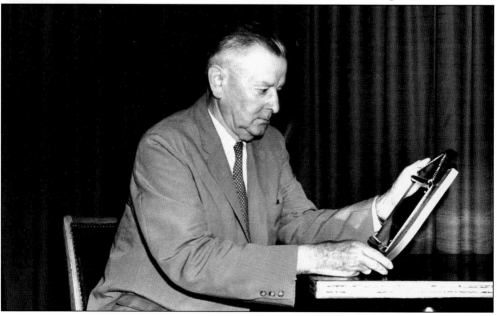

In 1976 and 1977, the president of the AMI was Harry Roberts. He is shown in the photograph at right. In the photograph below are James Paxson, right, and Jim Vattilano outside a mushroom house in 1966. The mushroom industry has experienced many changes since the time Roberts was an executive of the AMI.

Mushrooms do make mealtime magic. The message is hanging from the mushroom-filled ceiling in the photograph below. The mushroom industry has used a number of marketing slogans over the years to gain the attention of the mushroom-buying public. In the photograph at left, Milton Jackson receives a watch for his years of service to the AMI. He was an investor in the industry.

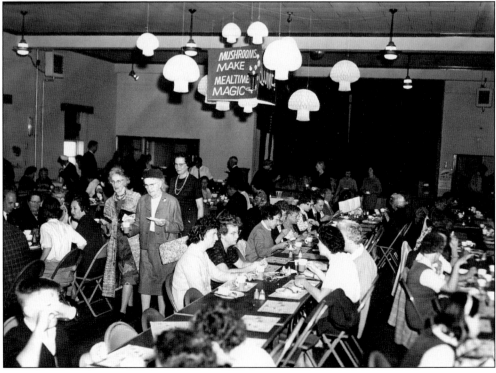

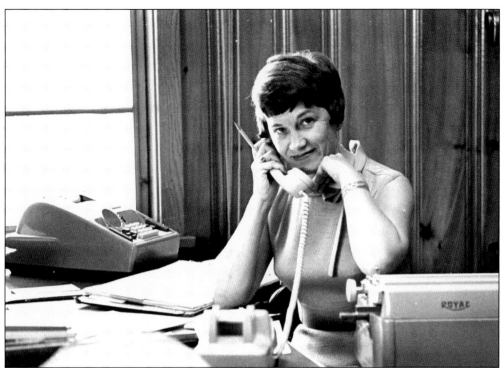

Hardworking Alma Rigler of the AMI is shown at her desk. She is on the telephone while working on reports. She has a pencil in her right hand and her Royal typewriter at one side and an adding machine to her right. Enjoying a mushroom event is Ed Leo and his wife, Janet, to the left. At right is Susan Peterson, chairman of the San Diego gathering. Ed was cochair. The Leo family has been in the mushroom business in Chester County for four generations.

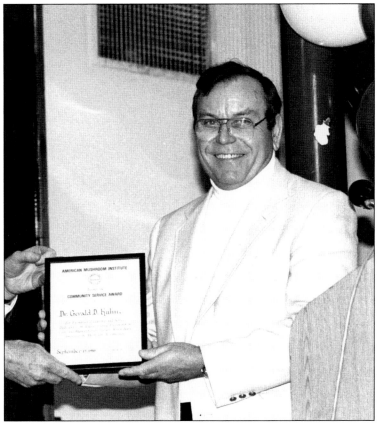

In the photograph at left, Dr. Gerald D. Kuhn of Pennsylvania State University's College of Agriculture receives an AMI award for community service. Kuhn is a food scientist. In the photograph below, Jack Czarnecki, who wrote about mushrooms, acts as a master of ceremony at a Book and Cook banquet. Czarnecki also owned Joe's Restaurant in Reading.

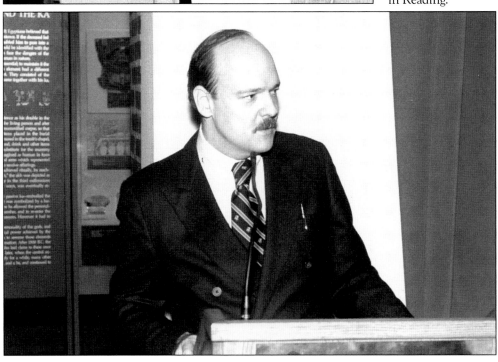

A number of people contributed to the success of the mushroom industry over the years. In the photograph above, taken in September 1983, is Pete Alonzo. The photograph below shows Joseph DiNorscia III (far left), a past president and director of the AMI. Dr. Cliff Keil of the University of Delaware; Paul Frederic of the Wilson Mushroom Company; and Robert Cantarera of Spawn Mate East are shown from left to right with DiNorscia.

The staff of the AMI puts in many hours preparing for the various public shows featuring the mushroom industry. In the photograph above is Luciano "Lucky" Fillippini of L&F Supplies at an AMI District VII meeting. He is shown with Alma Rigler, an honorary life member of the AMI. In the photograph below, members of the AMI gather around the conference table.

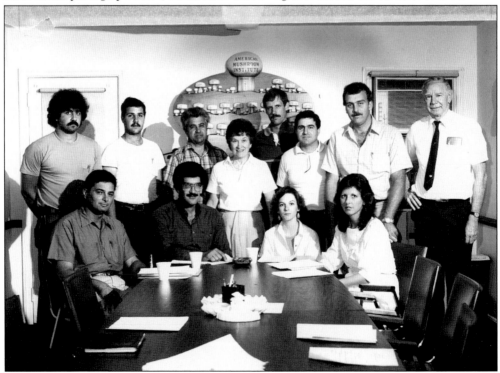

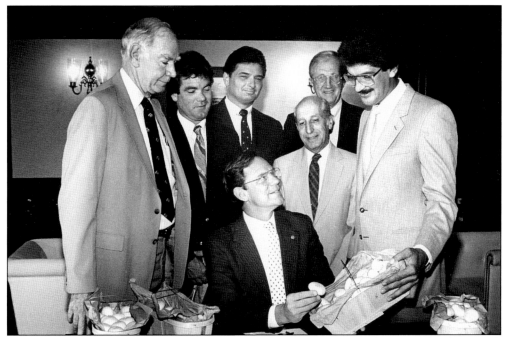

The executive directors of the AMI are responsible for promoting the industry. In the photograph above at the far left is Charlie Harris, who served as executive director from 1984 until 1990. The photograph below shows the board of directors for the years 1990 and 1991. Sitting from left to right are Carl Fields, Jim Angelucci, Louis DiCecco, and James Ciarrocchi. The second row shows, from left to right, Tom Brosius, Joe DiNorscia, Curtis Jurgensmeyer, Mike Pia, and Dave Carroll.

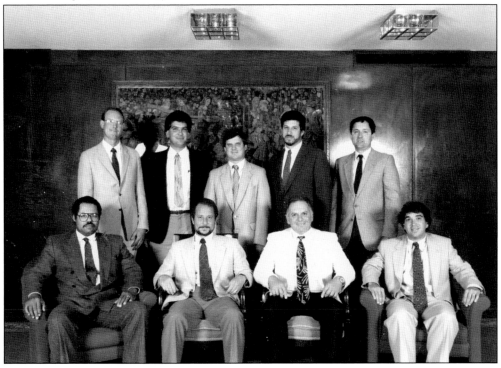

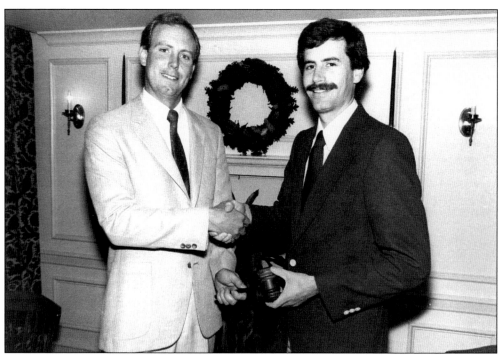

The mushroom industry in Chester County is dominated by family-run farms that have been in the same family for generations. Large factory farms are not seen in the county. In the photograph above, grower Gary Schroeder (left) accepts the gavel as chairman of the board of the AMI from Tom Brosius. To the right in the photograph below is his father, Charlie Brosius, and Ed Sannini.

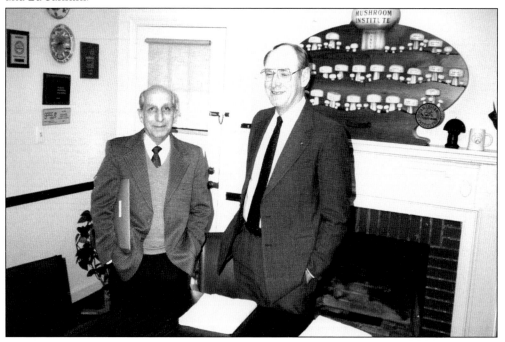

During the early 1980s, Jess Pusey, shown in the photograph above, was president of Mushroom Express of Avondale. The president of the AMI during 1984 and 1985 was Nazzareno (Naz) Paloni Jr., shown in the photograph below in front of an AMI banner on the left. With Naz Paloni are Claire Leo and Louis Pia. The Leo and Pia families are prominent in the Chester County mushroom industry.

The president of the AMI for 1986 and 1987 was Michael L. Hopkins. Hopkins, shown in the above photograph, was the proprietor of Greenhill Farms, Avondale. James Angelucci, left in the photograph below, is shown with Bill Daniels. Angelucci served as president of the AMI and was a member of the Community Awareness Committee and on a number of other committees.

Angelucci is general manager of Phillips Mushroom Farms of Kennett Square. He is shown on the left in the above photograph with Philip A. Roth of Apple Valley Farms of Fairfield. They attended a seminar at Dickinson School of Law in 1988 to discuss compliance with new governmental agriculture directives. In the photograph below, four supporters are honored. Joe DiNorscia is at right, and legislator Bill Roth is at left.

Members of the Yeatman family have been farming in Chester County since the 1700s. They started mushroom growing in the 1920s and now have a thriving family farm. In the photograph above, the Yeatman farm is visited by officials of the Commonwealth of Pennsylvania, including state officials Nick DiBenadictus and Ken Hollwell. The photograph below from 1985 shows officials being presented with, as the sign says, "Delicious Nutritious Mushrooms."

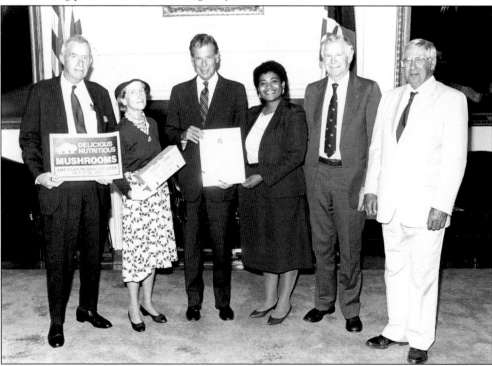

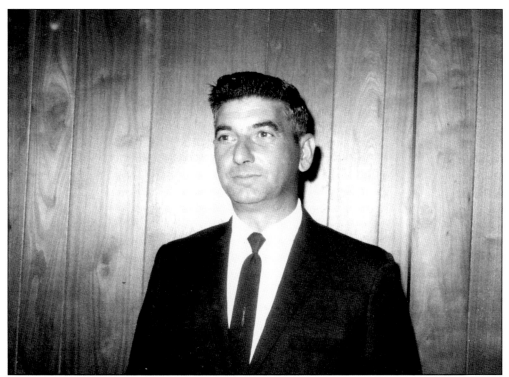

One of the early presidents of the AMI was Joseph Caligiuri, who served in 1969 and 1970. He is shown in the photograph above. The photograph below was taken at a political event. The basket of mushrooms is being held by supporters of Pres. Ronald Reagan and Vice Pres. George Bush.

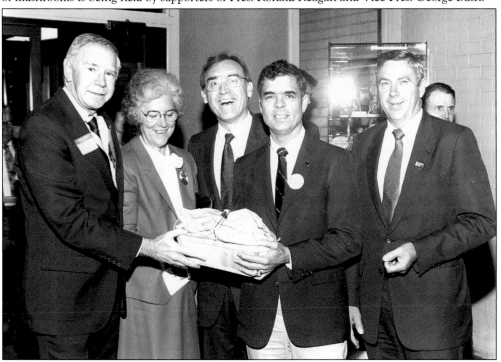

Part of the mission of the AMI is to provide information about the industry. A number of farm tours are held each year. In the photograph below, William Ricchutiti, in the center of the photograph, is shown explaining a point about growing mushrooms to a group from the National Nutrition Association. The photograph at left shows a group of men at one of the area's mushroom houses.

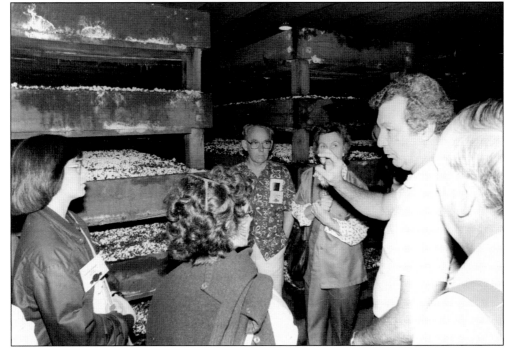

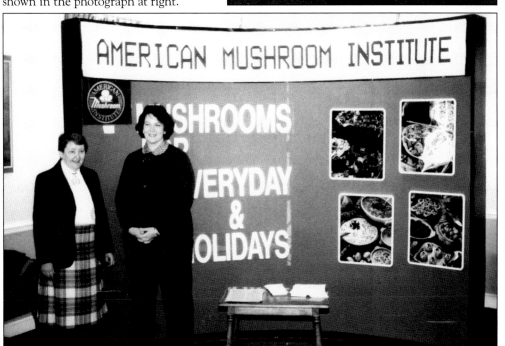

The idea for the AMI began prior to America's involvement in World War II by growers in Chester County. The growers wanted an organization to act as an advocate for the mushroom farm community. The AMI did so by honoring those who worked in the industry, see the photograph at right, and by presenting displays at many different conferences. The photograph below shows mushrooms being promoted for "everyday and holidays." Al Sharpless and Lou Lescabara are shown in the photograph at right.

AMERICAN MUSHROOM INSTITUTE

MUSHROOMS
EVERYDAY
&
HOLIDAYS

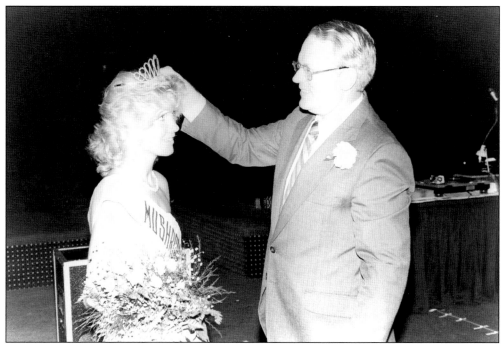

One of the premier annual events in Kennett Square is the mushroom festival. In the photograph above, Congressman Joseph Pitts, then a member of the Pennsylvania House of Representatives, crowns the first Miss Mushroom, Wendy Kimmel, in 1987. Pitts has been a strong supporter of the mushroom industry. Kimmel was a senior at Kennett High School. In the photograph below is an AMI promotion involving a rowing oar given by the French Mushroom Growers Association.

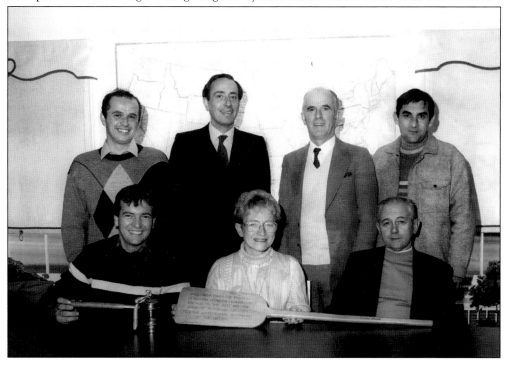

Three

MUSHROOM SCIENCE

Improvements have been
made over the decades in
the way mushrooms are
grown. Pennsylvania State
University has been one of
the major partners of the
AMI. The university's School
of Agriculture has conducted
many experiments. In the
photograph on this page
a doctoral student, Mike
Nicholson, is shown as he
is studying single sporing.
This section of the book
will also look at some of the
technical improvements made
in handling and packaging
mushrooms. Science has
made mushroom growing
more efficient over the years,
thus allowing the farmers to
continue to make a profit. The
cost of growing mushrooms,
especially labor expenses,
has greatly increased in
the last century.

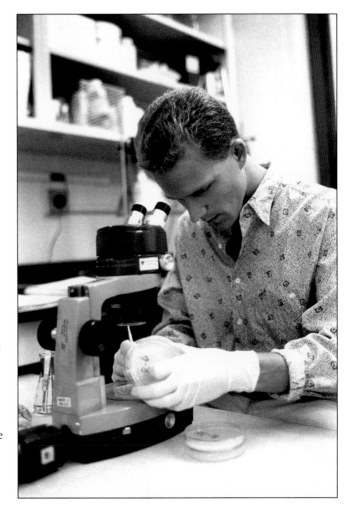

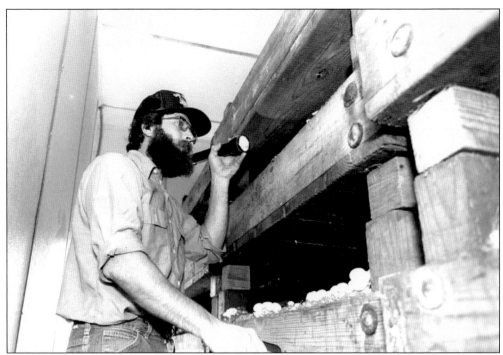

Pennsylvania State University has participated in a number of test demonstrations of growing mushrooms. In the photograph above, Tom Rhodes checks the latest crop at the test demonstration facility at the university. The growing beds are of the same type as used in Chester County mushroom houses. The photograph below shows an instructor and student examining a tray of white button mushrooms.

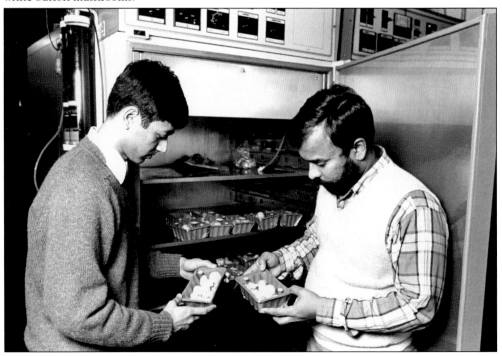

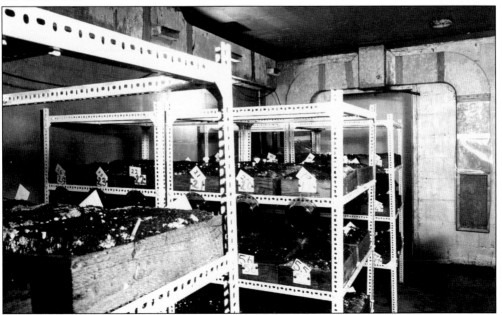

The doctoral programs at Pennsylvania State University give students a chance to work in all areas of mushroom growing. In the 1920s, the university became the first land-grant college to initiate a comprehensive mushroom research program. In the photograph at right, student Britt Bunyard is setting up an electrophoresis process. The photograph below shows monospore cultures in one of the laboratories.

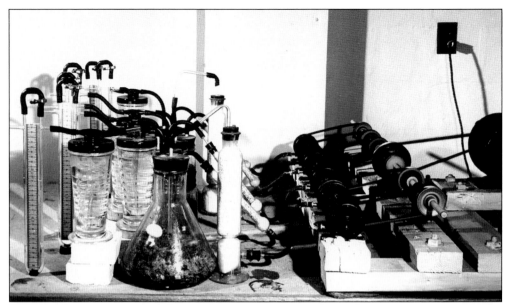

Specialized equipment is needed to conduct experiments on the mushroom-growing process. The laboratories at Pennsylvania State University contain the necessary apparatus for the scientific tests. In the photograph above, the apparatus depicted was used in the Agaricus campestris *bisporus* metabolic gas study. The photograph below depicts two scientists using a microscope to study spores.

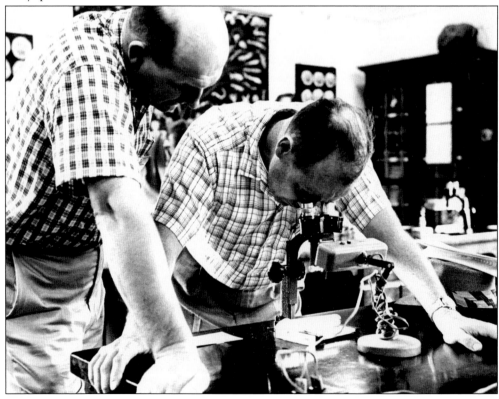

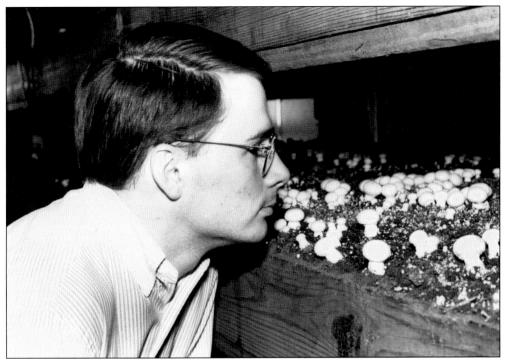

All stages of the growing process are closely watched and documented during the experiments conducted at Pennsylvania State University. In the photograph above, a university employee is examining one of the later stages of development. The photograph below shows a first cutting of an experimental crop during day 13 of the test.

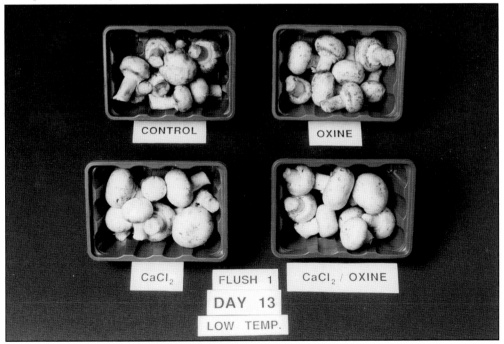

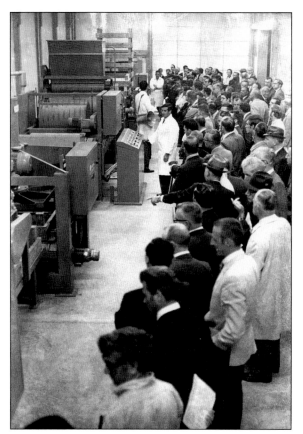

Pennsylvania State University held an open house at its new mushroom test demonstration facility in May 1970. Environmental conditions inside mushroom houses are regulated by control panel units, as shown in the photograph at left. The controls were said to operate more easily than a color television set. The photograph below shows an announcement being made concerning the test facility.

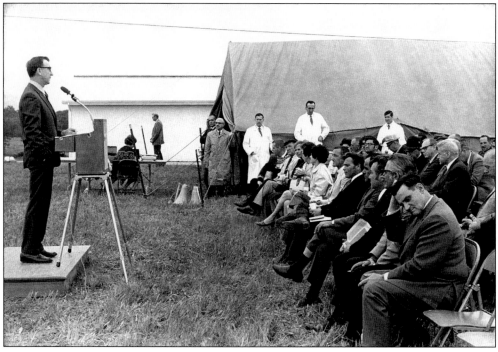

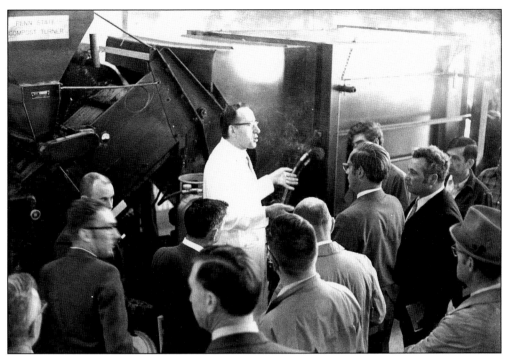

The photograph above shows Dr. Lee Schisler, Pennsylvania State University Department of Plant Pathology, telling growers about the features of an experimental compost turner with ricker attached. The photograph was taken at the university's open house for its demonstration facility in May 1970. The photograph below shows some of the mushroom and university officials attending the open house.

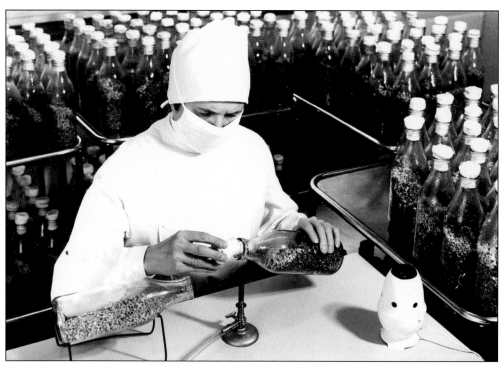

The photographs on this page show part of the spawn process. In the photograph above, a worker is carefully conducting the spawn inoculation. The photograph below is titled "Here germs die so that mushrooms may live better." The steel cylinder, 15 feet long, sterilizes bottles in which the spawn will live when it leaves the test tubes.

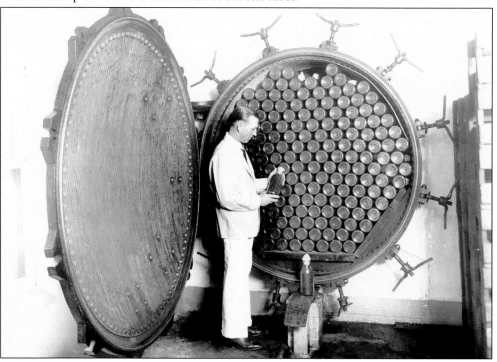

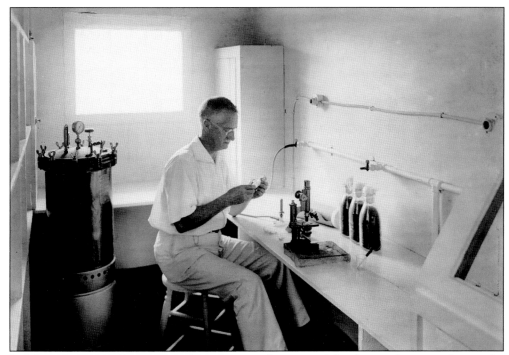

Led by internationally recognized scientists and supported by the mushroom industry, the Pennsylvania State University program developed improved composts and production practices that were adopted by growers worldwide. The university's work also helped Pennsylvania retain its leadership in United States mushroom production. The photographs on this page show testing done at different times on spawn.

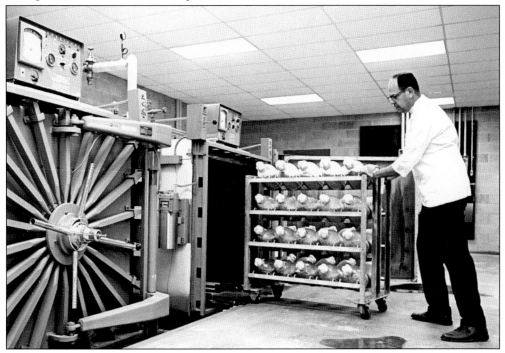

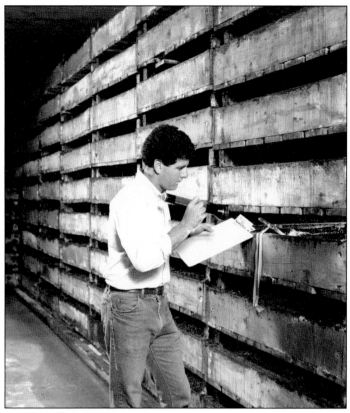

Chester County mushroom farmers have learned from the studies done at Pennsylvania State University. The growers have incorporated the findings into their growing process. Chester County mushroom growers retain their designation as the top producers of mushrooms because they stay abreast of the latest growing trends. In the photograph below, Bob Bennett, center, discusses mushroom-growing techniques. In the photograph at left, careful records are being kept of the progress of a mushroom crop.

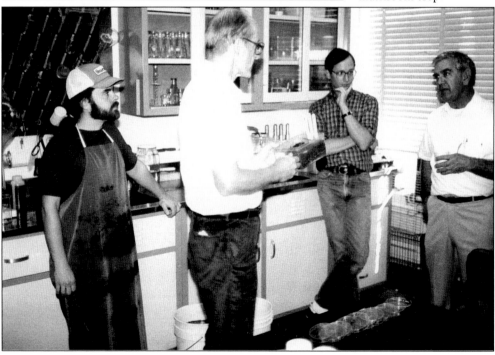

In the photograph at right, a worker is checking the progress of the maturing of spawn. Spawn must grow in bottles before it can be put on the mushroom beds. Without quality spawn, mushroom crops will not be successful. In the photograph below, Tim Hetrick and Fiona Davenport, graduate students at Pennsylvania State University, are assisting in the preparation of compost for spawn.

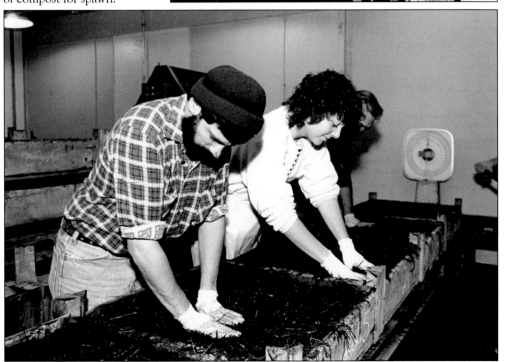

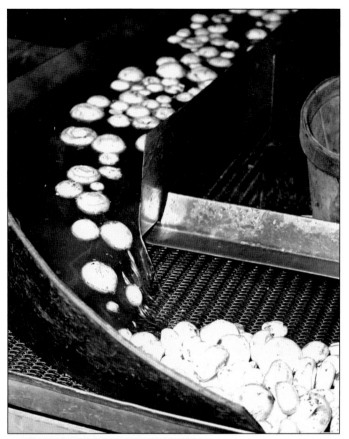

All the scientific experiments and testing of mushrooms result in consumers getting fresher and tastier mushrooms. In the photograph at left, mushrooms are rounding the bend of a belt and heading to another stage of processing. In the photograph below, mechanical harvesting is taking place. The machine automatically grades and separates two sizes of the mushrooms.

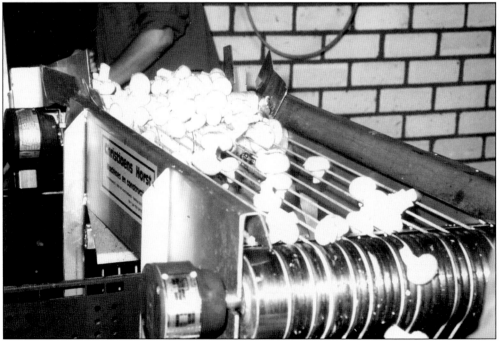

Pennsylvania State University's research dealing with the cultivated mushroom and problems related to its culture was begun in the mid-1920s. In 1928, the first mushroom research facility was built on campus and expanded in 1934 with money given by the Mushroom Growers Cooperative Association of Kennett Square. Research is being completed in the photograph at right, while the photograph below shows a net-cutting machine.

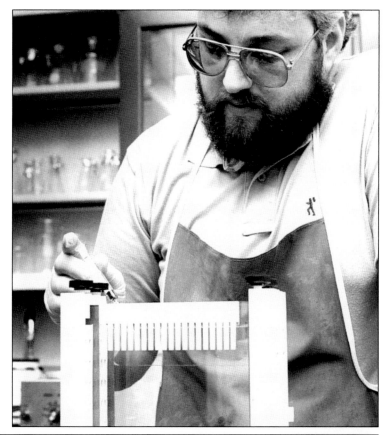

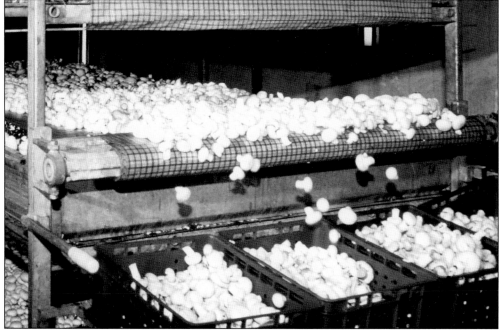

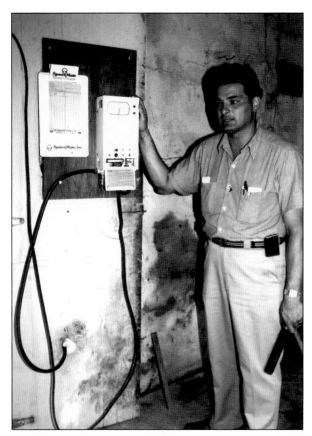

In June 1984, Nazzareno (Naz) Paloni Jr. was part of an article for the AMI newsletter concerning the operation of his farm. He was president of the AMI during 1984 and 1985. In the photograph at left, he shows his carbon dioxide monitor and how it has helped with his cropping. In the photograph below, Naz tells about his peat moss mixer.

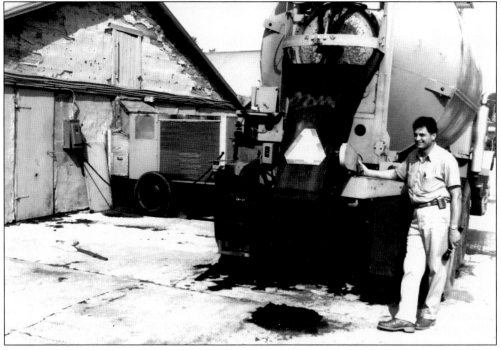

Mushroom growing was begun in 1885 by William Swayne, a successful florist in Kennett Square. He sent to England for spawn. He built the first mushroom house in the area, and his son, J. Bancroft Swayne, returning from college, took over the mushroom business and made it a commercial success, eventually developing a spawn plant and a cannery in addition to the growing houses. The photograph at right is from the Swayne cannery. The photograph below shows glass packs being readied for capping at another plant.

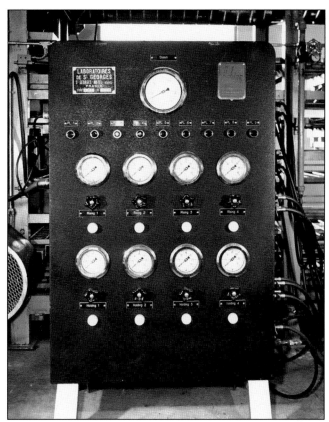

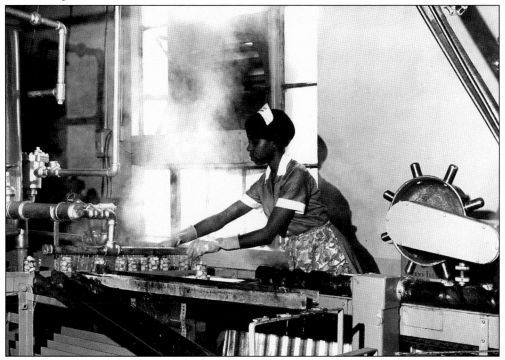

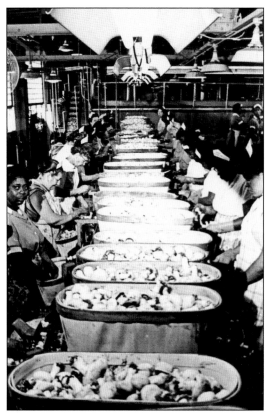

The photograph at left shows buckets and buckets of mushrooms being processed by a small army of workers. In the photograph below is an air-washed, germ-proof, and daily-sterilized laboratory. The spawn is about to be transferred from test tubes to sterilized spawn bottles. Operators wear masks to prevent contamination of the spawn. The spawn thread-roots grow in the germ-proof bottles for six weeks.

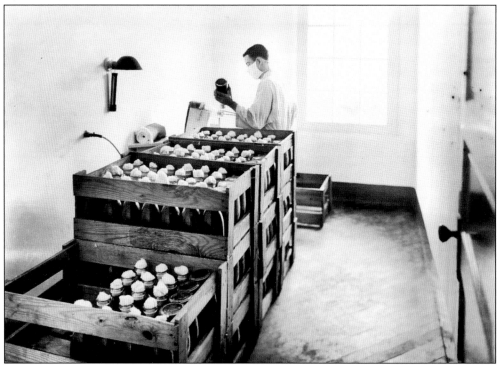

Four

MUSHROOM PROMOTIONS

Members of the AMI and its Community Awareness Committee travel far and wide to promote mushroom sales and use of mushrooms in dishes. In the photograph on this page, AMI has a display at a Trans World Airline event. As the sign says, "Mushrooms go with everything." Mushrooms can also be transported almost anywhere. One of the posters is for airfreight shipments. The sign to the left is for perishable air transport. Lobsters are part of the show, and the man in the middle is holding a crustacean.

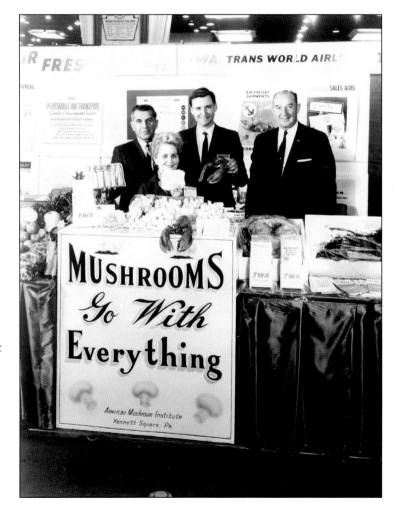

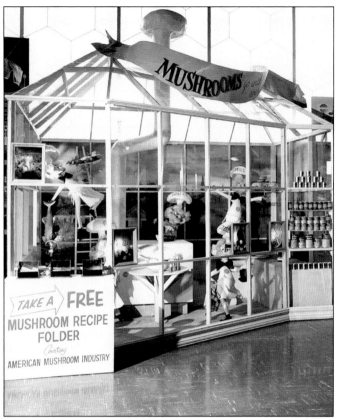

One of the AMI's promotions was at the world's fair in New York City during 1964 and 1965. The photograph at left shows the display featuring the "mushrooms go with everything" promotion and uses mushroomlike characters. Free mushroom recipe folders were distributed. In the photograph below, a promotion of steak and mushrooms was featured at a grocery store.

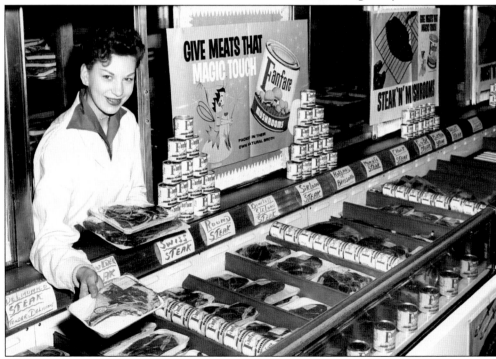

Two visitors to the world's fair in New York admire the AMI's display in the photograph at right. Mushroom promotions are also undertaken closer to home. In the photograph below, Buona Foods of Avondale is selling a bowl of breaded mushrooms for $1.25. Mushrooms are a favorite at many of the Chester County restaurant festivals.

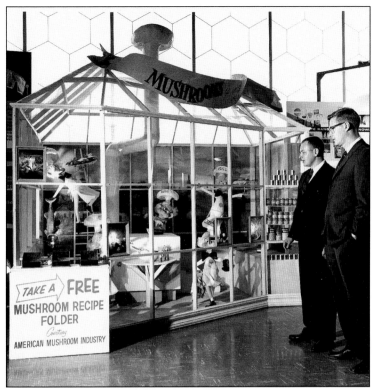

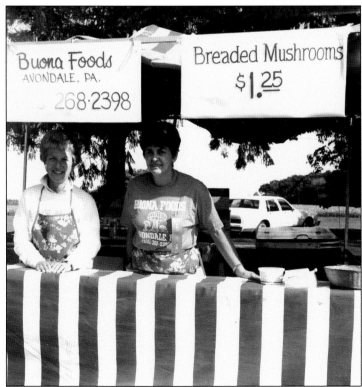

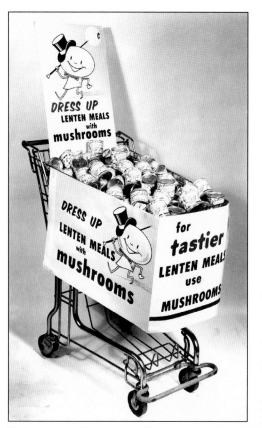

Mushrooms are a part of meals at any time of the year and with most holiday celebrations. The photograph at left has a store display that urges shoppers to "dress up Lenten meals with mushrooms." The promotional photograph below is for Jacob's Mushroom Spawn company of West Chester. The bottle at left has six-week-old spawn while the center bottle has spawn ready to be planted. The cardboard containers have dried mushroom spawn.

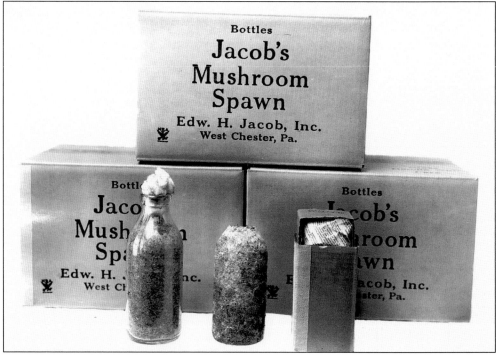

Mushroom designs can be found on many different types of products, from tapestries to clothing. A store in Kennett Square, the Mushroom Cap, carries all types of mushroom-themed products. The shop also sells fresh mushrooms and contains a mushroom museum. Two publicity photographs are on this page. The photograph below is in connection with a New Year's celebration promotion.

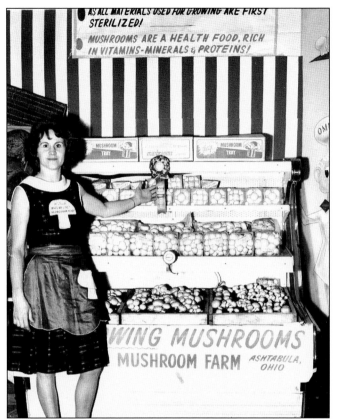

Mushroom growing takes place across the country, and the photograph at left features an Ohio company. The woman's mushroom-shaped tag references the old television show *What's My Line*. "I'm a mushroom picker," the label says. The display points out all materials used for growing are first sterilized and that mushrooms are a health food. In the photograph below are some Chester County shiitakes.

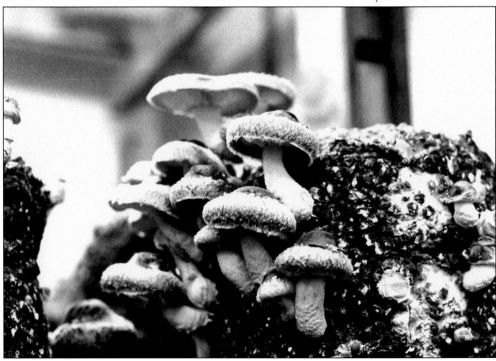

Mushrooms have been used as ingredients in many food demonstrations. The photograph at right shows chef and Reading restaurant owner Jack Czarnecki. He is with Craig Handley. He also wrote about mushrooms. In the photograph below is a display depicting aspects of a typical mushroom farm. The display is by Associated Mushroom Industries of Berks County. Berks County is adjacent to Chester County.

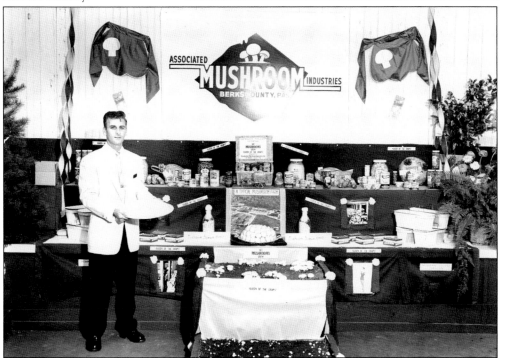

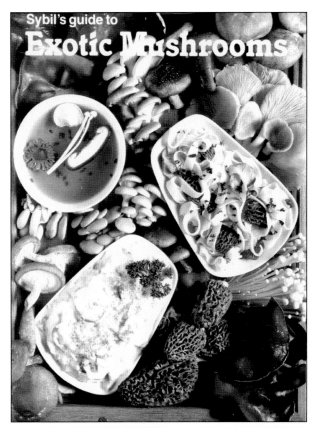

Sybil's guide to
Exotic Mushrooms

For many years, mushroom growing in the United States and especially Chester County, the Mushroom Capital of the World, was limited to white button mushrooms. In the photograph below is a close-up view of two of the white button variety. Chester County growers were among the pioneers in producing exotic mushrooms, such as crimini, portabella, maitake, shiitake, enoki, and oyster. The promotional photograph on the left is an exotic mushroom guide.

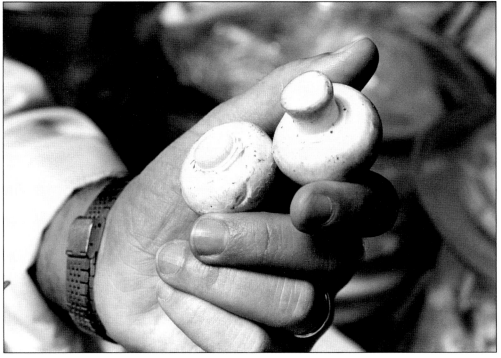

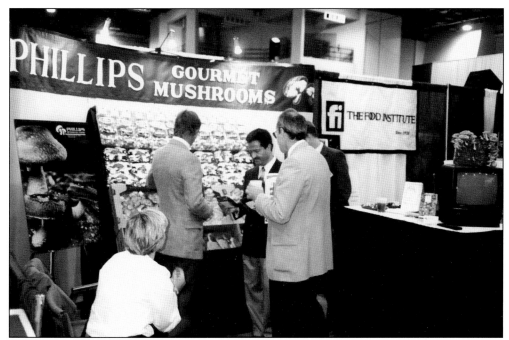

Phillips Mushroom Farms in Kennett Square is a leader in the gourmet mushroom business. The photograph above is a view of one of the Phillips display booths. Phillips decided to quit growing white mushrooms in 1989 and concentrate on specialty mushrooms. The company began growing shiitake and portabella mushrooms and became the first commercial farm to put portabella mushrooms on the market. The photograph below is a view of the 1966 booth from an American Restaurant Association show in Chicago.

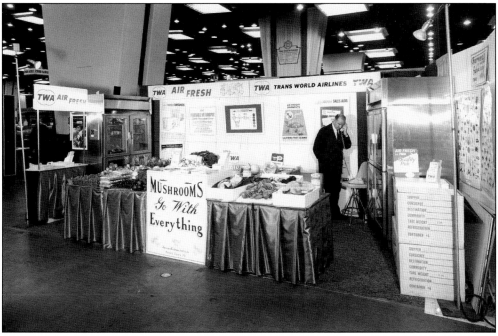

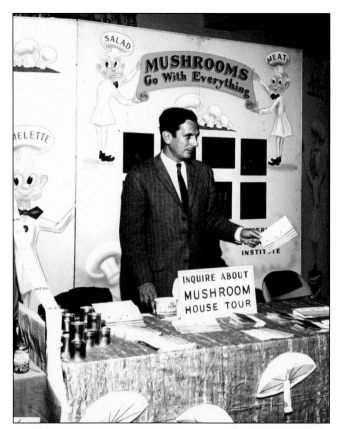

To correct myths about the mushroom industry the AMI provides educational materials to the public and at times gives mushroom farm tours. The Community Awareness Committee has also created a Web site to provide information on the growing process and to highlight family-owned businesses. The photograph below is from an AMI booth done in connection with the Mushroom Canners League.

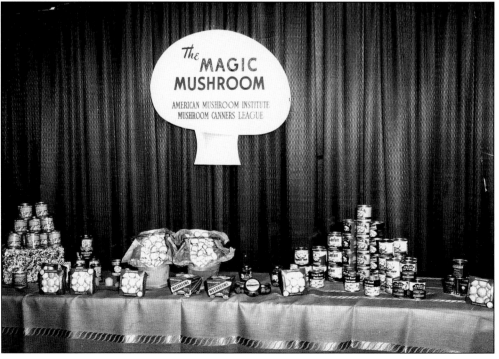

Mushrooms are a healthy food choice. Cultivated mushrooms are low in calories and are sodium free, fat free, and cholesterol free. Although mushrooms are often grouped with vegetables and fruits, they are actually fungi. For that reason, they are in a class of their own, nutritionally speaking. Mushrooms do share some of the benefits of fruits and vegetables. The photograph below proclaims mushrooms to be a delight for weight watchers.

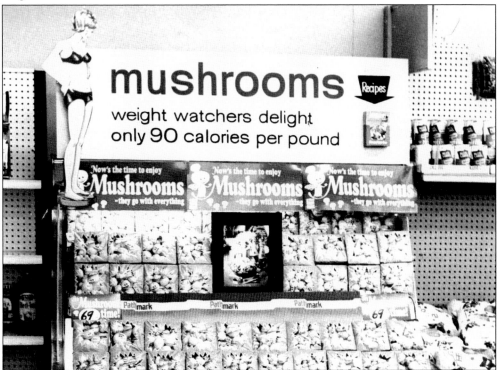

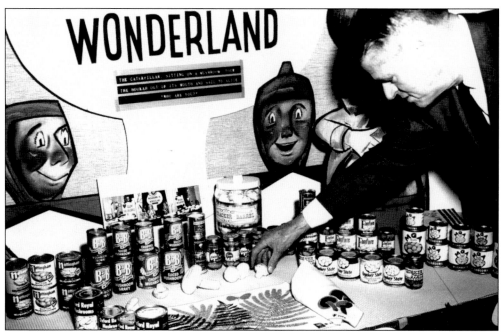

Mushrooms are mentioned throughout history and have been featured in literature, including *Alice in Wonderland*. The photograph above has an Alice theme with the quotation "The caterpillar, sitting on a mushroom, took the hookah out of its mouth, and said to Alice, Who are you?" The photograph below shows a number of varieties of pickled mushrooms and mushroom salads.

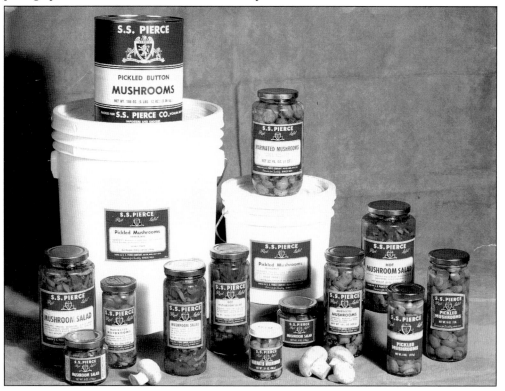

Mushrooms in cans were showcased in many grocery stores in years gone past. Today fresh mushrooms are featured. The photograph at right shows a number of different brands, including Quaker State and Keystone mushrooms, made in Pennsylvania. The photograph below has other varieties of mushrooms, and the promotion says mushrooms give meats that magic touch. The cost is 29¢ per can for one of the special sale items.

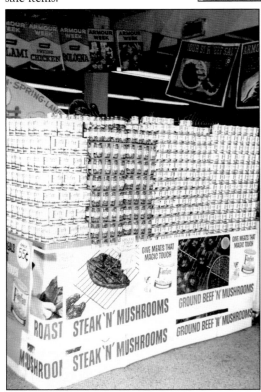

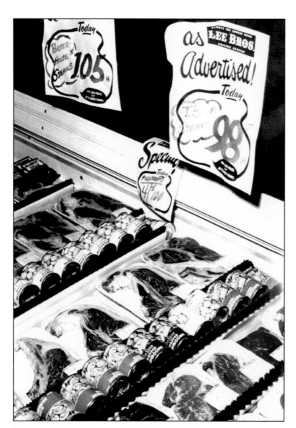

A special deal was offered on mushrooms in the left-hand photograph. A shopper could take home four cans for $1. An even better bargain at this Lee Brothers store was the 98¢ a pound T-bone steaks. The sign says the store always has the lowest price and smiling service. The photograph below features fresh and canned mushrooms.

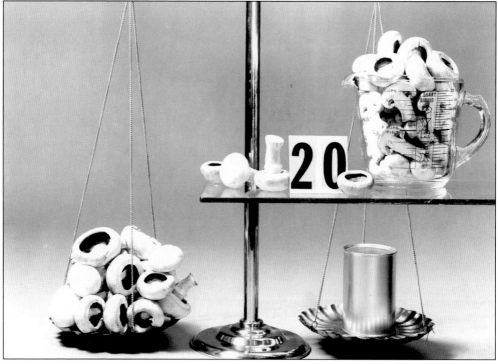

Many restaurants in the heart of Chester County's mushroom country feature different types of mushroom soup. Each has its own special blend. Longwood Gardens, the famous gardens of the Du Pont family, is located just outside of Kennett Square and features mushroom soup in its restaurant. The photograph below is an AMI display, and part of its message is that mushrooms add pizzazz to menus.

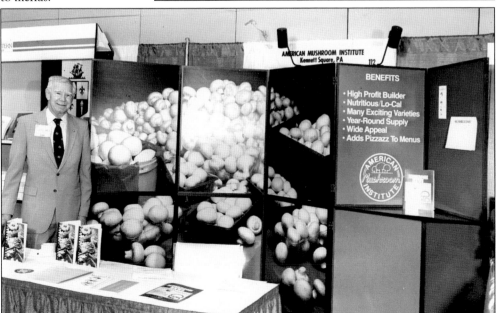

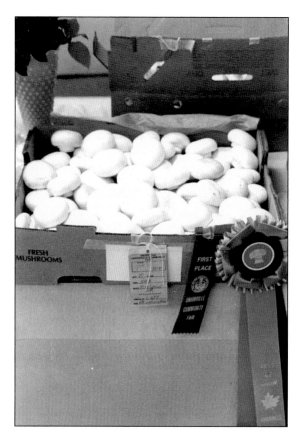

A number of Chester County communities hold fairs. Homegrown foods and baked goods are judged as part of the activities. Mushroom judging has been a part of the Unionville Country Fair for years. Unionville is just north of Kennett Square. In the photograph at left is a first-place winner. In the photograph below is a Best of Show winner. The Best of Show is noted to be Menu Mate's three-pound fancy.

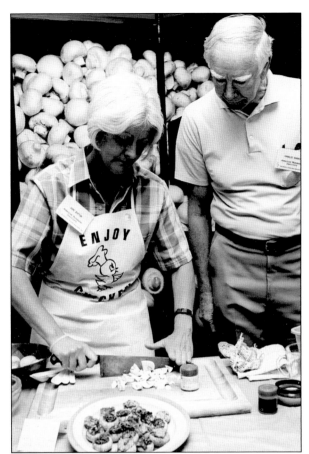

Charlie Harris, executive director of the AMI from 1984 until 1990, attended many of the promotions and shows affiliated with the mushroom industry. In the photograph at right, Harris looks over the shoulder of Jane Buffum of the AMI as she slices some mushrooms. In the photograph below, Harris talks with Shirley Staples of Tyler, Texas.

Mushrooms have proved to be popular among families in the United States over the years. During one of the food shows, AMI personnel identified Mr. and Mrs. G. W. Harris of Stone Harbor, New Jersey, as "typical of the young married couples who use our product every week." The photograph below shows an AMI hostess preparing food for a visitor to the booth.

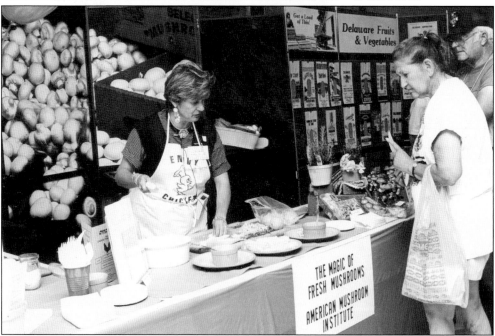

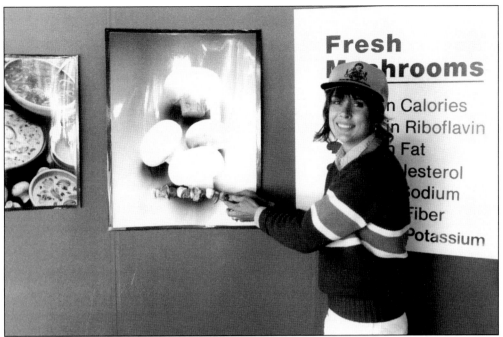

Mushrooms can be used to enhance many meals. In the photograph above, Katherine Tyler, a lamb producer, points to an illustration of a shish kebab of lamb featuring mushrooms. Tyler attended mushroom day at a local fair. In the photograph below, Cub Scouts from Chadds Ford crowd around a mushroom-growing display at a local fair. Chadds Ford is just east of Kennett Square.

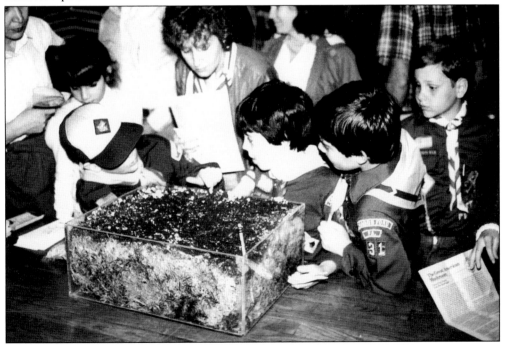

The photographs above show a box of packaged Country Fresh mushrooms from Avondale in the heart of Chester County. Country Fresh is unique among the nation's fresh mushroom suppliers. It is one of the first cooperatives of individual mushroom farms. Each of the six grower/owners represents an average of three generations in mushroom farming. The photograph below touts mushrooms "as the smarter vegetable." Pennsylvania state representative Art Hershey is at left.

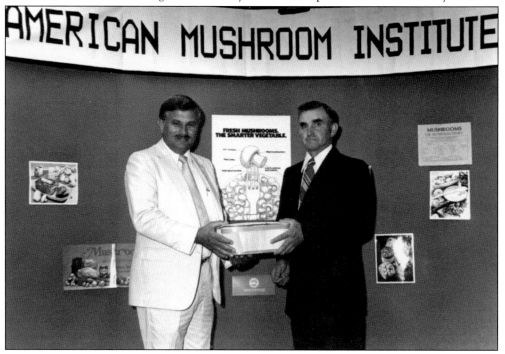

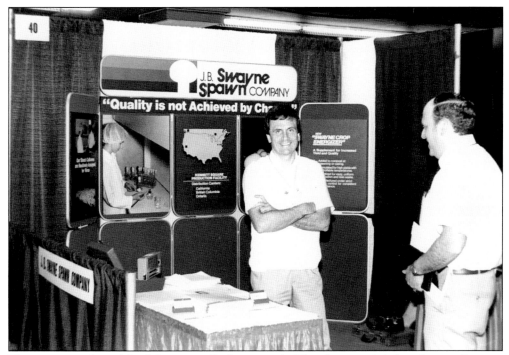

The various trade and food shows usually draw crowds. The photograph below shows a Country Fresh mushroom company display at a food show. Next to the mushroom display is one for Frank Perdue's chickens, and an Archway cookie display is seen in another aisle. In the photograph above is a shot of the J. B. Swayne spawn company at the 1985 national mushroom conference. Bill Barber and Ed Leo are shown from left to right.

MUSHROOM NEWS

EMPHASIS ON EXCELLENCE

5TH NORTH AMERICAN MUSHROOM CONFERENCE

MARCH 1985

AMERICAN MUSHROOM INSTITUTE

0617 - AMI - FLYER - GREY 0063 - AMI - AUGUST
SHOOT - ME NEG - REG EXPOSURE 100% LINE NEG.
SHOOT - NEG UNDER EXPOSE - USE TO MAKE 60% RAY - BEN FTK.

The front page of the *Mushroom News* for March 1985 sums up the feeling of the AMI. The issue was devoted to "Emphasis on Excellence." The issue was for the fifth North American Mushroom Conference. The Pennsylvania mushroom industry was represented at the January 1967 inauguration parade for Gov. Raymond P. Shafer. In the photograph below, the dancing mushroom characters promoted different uses of mushrooms.

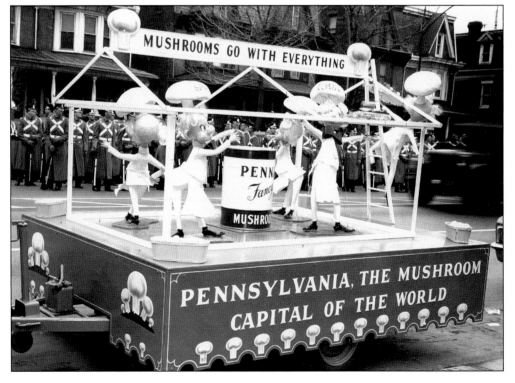

Five

MUSHROOM CELEBRITIES

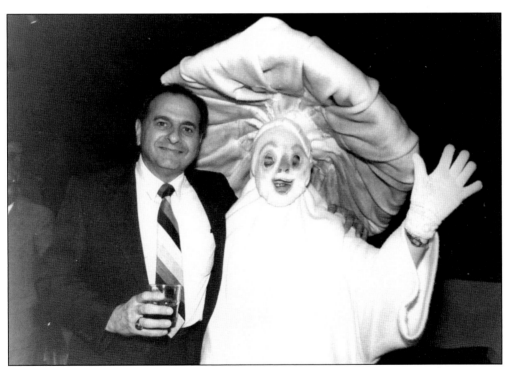

The mushroom industry has drawn a lot of celebrities to its celebrations. Famous television stars have been parts of promotions, and the AMI has been successful in bringing its message about the industry to politicians in Washington, D.C., Harrisburg, and West Chester, the county seat of Chester County. Many of the elected representatives have joined in the festivities in Washington, Pennsylvania, and Chester County. The industry has also had a lot of fun with its mushroom characters, as seen in the photograph on this page. Besides the life-size mushroom, mushrooms have been known to be placed as patterns on clothes.

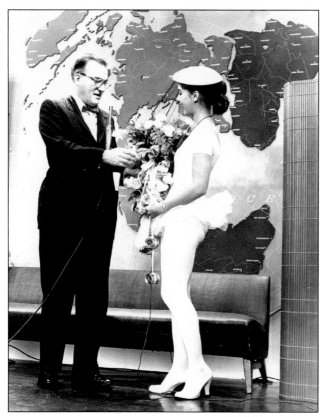

A star in the early days of television was Dave Garaway. He hosted a morning show on NBC. In the photograph at left, Garaway takes part in a mushroom promotion and accepts flowers from an industry representative. The mushroom industry has crowned a number of mushroom queens over the years. The first national mushroom queen is shown surrounded by flowers and, what else, mushrooms.

Then mayor of Philadelphia, Wilson Goode took part in one mushroom publicity event. He is seen in the photograph above with Libby Goldstein, a Philadelphia writer, and Boyd Wolff, who was the Pennsylvania secretary of agriculture. Goode is standing at right. Mushrooms were used in many cooking shows such as Breta Griem's show *What's New in the Kitchen*, which aired from 1949 until 1962 in Milwaukee.

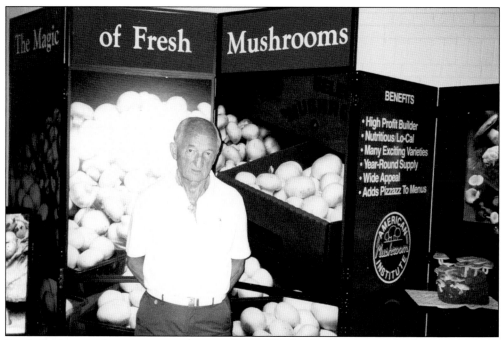

Frank Perdue was for many years the president of Perdue Farms, one of the largest and most well-known chicken companies in the nation. He is seen in the photograph above before an AMI display at a food conference. In the photograph below at right is Pennsylvania senator Noah Wenger, who represented part of the area surrounding Chester County's mushroom-growing area. Grower Charlie Brosius is next to Wenger.

Pat Ciarrocchi is a Philadelphia news reporter and television celebrity. She is from a Kennett Square mushroom-growing family. In the photograph at right, she is seen as a judge at the fourth annual mushroom recipe cook-off contest at the Unionville Community Fair. In the photograph below, she is seen on the left at a business expo with members of another county mushroom family. With Ciarrocchi are Michael and Nancy Pia.

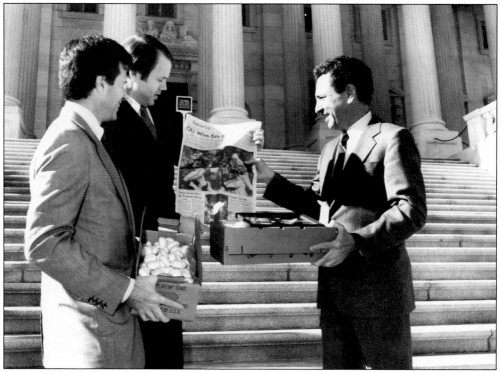

Over the years strong supporters of the AMI have been members of the Pennsylvania delegation to Congress. Mushroom events are held yearly in the nation's capital. In the photograph above, longtime senator Arlen Specter (right) is holding a box of mushrooms as he looks at a newspaper. In the photograph below, third from right, is former congressman Robert Walker.

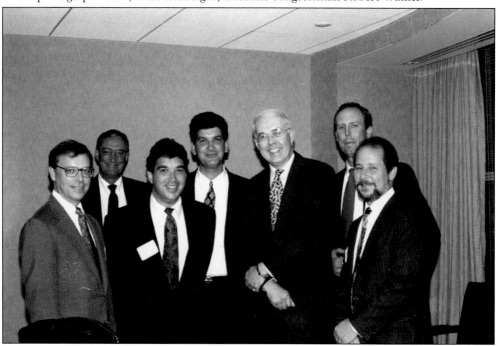

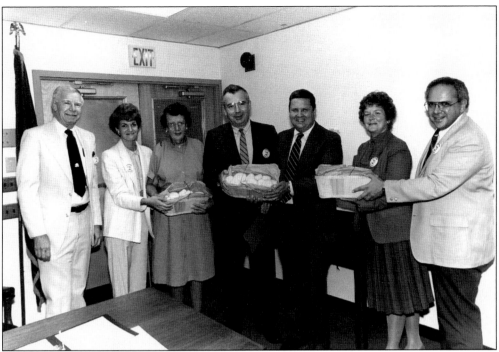

On the local level, the Chester County commissioners have also supported agricultural endeavors in the county, including the mushroom industry. In the photograph above are three members of the Chester County commissioners. Third from left is commissioner Patricia Baldwin. Next to her, holding the mushrooms, are commissioners Bob Thompson and Earl Baker. In the photograph below is Pennsylvania secretary of agriculture Boyd Wolff with grower Charlie Brosius, standing, and Kay Cushing, executive vice president of Ketchum Public Relations of Pittsburgh.

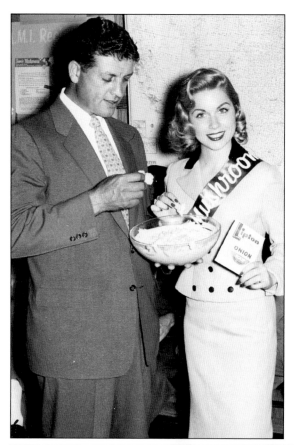

Chester County is large enough to have multiple congressional districts. In the 1970s, Richard Schulze, who lived in Paoli, represented the eastern section of the county. He is shown in the photograph below with a basket full of agricultural products from Pennsylvania. He is holding a container of Chester County mushrooms. In the photograph at left is Vincent A. Leo, founder of Modern Mushroom Farms. The promotion is for Lipton onion soup.

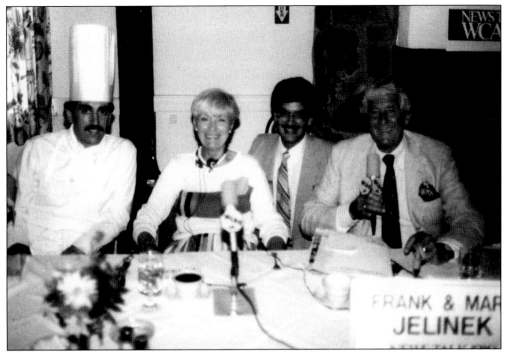

Mushrooms have been the topic of a number of cooking shows on radio and television over the years. In the photograph above are Frank and Mary Jelinek. The couple hosted cooking and restaurant review shows in the Philadelphia area for years. The photograph below was taken in October 1955 during a television show on *Cooking with Mushrooms*.

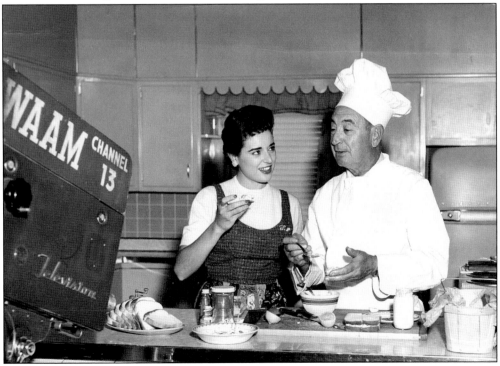

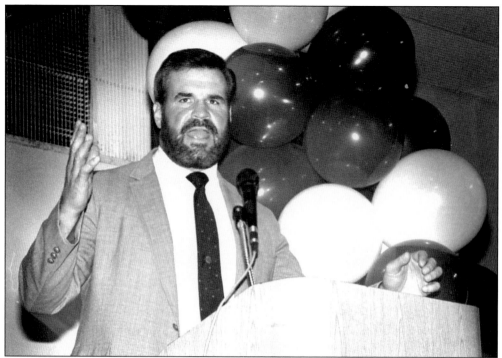

Sports stars have also taken part in mushroom-related events. In the photograph above is Bill Bergey, a former All-Pro middle linebacker with the Philadelphia Eagles. He played in Philadelphia from 1974 until 1980. He spoke at one of the Kennett Square Mushroom Festival events. In the photograph below is former Pennsylvania governor Dick Thornburgh. He is holding a pen and sitting in the middle seat.

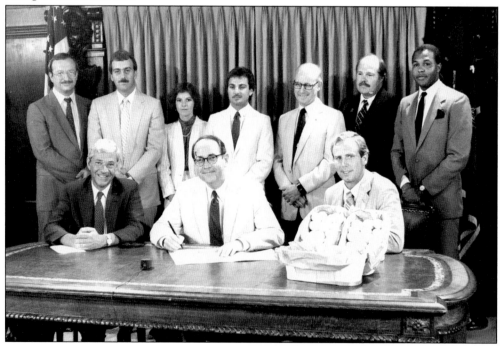

Mushrooms can appear in many sizes and shapes and on just about any type of product. The man in the photograph above at a mushroom promotion booth is wearing pants adorned with mushrooms. The photograph below shows Jennifer Armitage at the fifth annual cook-off at the Kennett Place Restaurant. She receives her door prize from Sonny Pizzini, cochairman of the event.

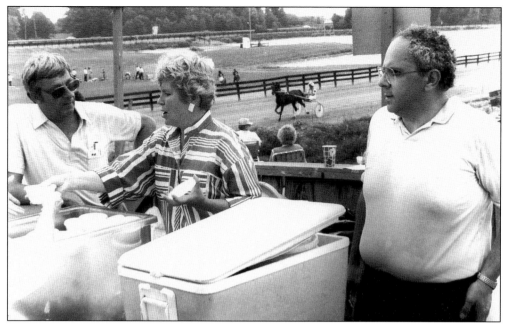

Representatives of the mushroom industry appear at many different types of events to promote their products. In the above photograph, mushrooms are being distributed during a horse-racing event put on by a Chester County Lions Club. The photograph below shows a scene in Kennett Square with a banner proclaiming American Mushroom Week from October 7 until October 12.

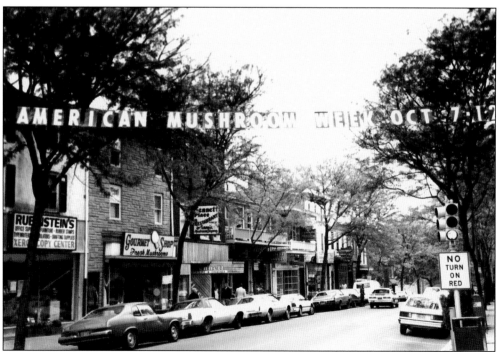

Even animals and clowns like mushrooms. In the photograph above, a clown stands at the base of a mushroom display that includes pictures of mushrooms and a poster that lists the attributes of fresh mushrooms. In the photograph below, the animals, a bunny and a cow, are looking over a display of fresh mushrooms sponsored by the AMI.

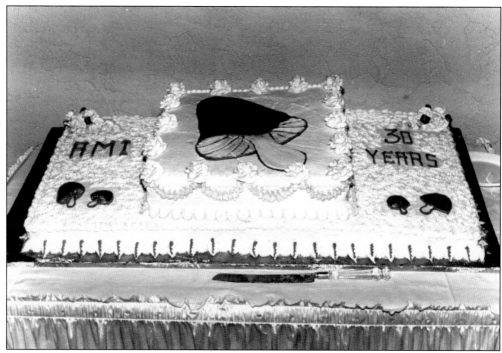

The AMI has been in existence for more than a half century. The AMI has taken part in many different promotions, parades, and celebrations. The photograph above shows a birthday cake that was made for the AMI's 30th anniversary. Of course, the cake features mushrooms. In the photograph below, Miss Mushroom 1987, Wendy Kimmel, greets onlookers as Louis Caputo drives her during the fourth annual Unionville Community Fair parade.

Six

MUSHROOM LIFE

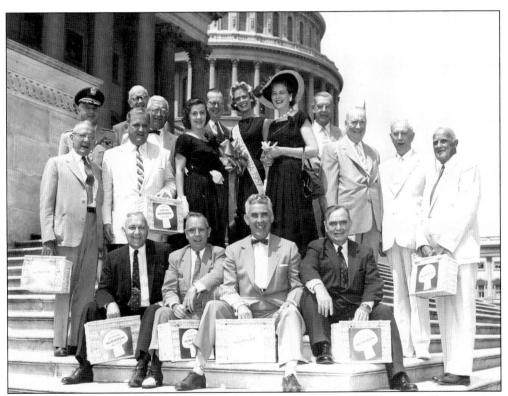

One of the goals of the AMI is the national promotion of sales of mushrooms. The group has taken its message to Washington, D.C. The photograph on this page was taken on the steps of the Capitol in 1957. The dignitaries have suitcases filled with mushrooms presented by the AMI. Most of the people are members of Congress, including Speaker of the House Joseph W. Martin, seated in the front row on the far right. Third from the left in the back row is Congressman Paul Dague, who represented Chester County. The woman wearing the sash is Miss Pennsylvania Ellen Krauss.

Mushroom farming now takes place all year. Mushrooms mature at varying times, so picking by hand is continuous for 6 to 10 weeks for every crop. The tray or bed is then completely emptied, and the entire growing area is pasteurized with steam before a new crop is started. The two photographs on this page show the AMI sign in different seasons.

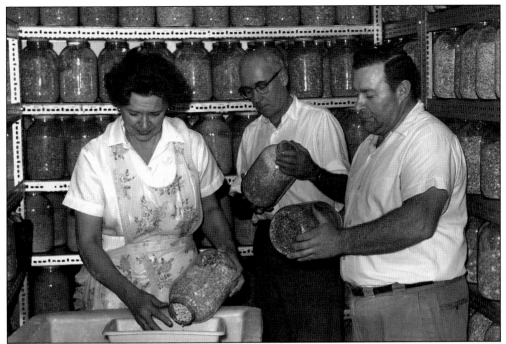

Because sterile conditions are required to begin the life of a cultivated mushroom, the entire operation begins in a laboratory. The spores, or natural seeds of the mushroom, are so minuscule that the mushroom grower cannot handle them. Laboratory personnel inoculate sterile cereal grains with the spores and incubate them until a viable product is developed. These grains become spawn, which can then be sown like seed. In the above photograph work is being done in a spawn laboratory. The photograph below is a close-up of grain spawn.

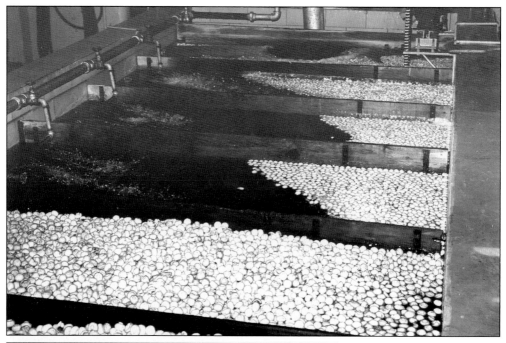

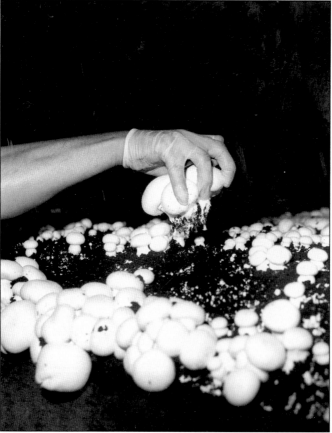

At the farm, the grower carefully prepares the compost, the basic growing medium for mushroom production. Two types of starting material are generally used for mushroom compost: synthetic compost consisting of wheat or rye straw, hay, and/or crushed corn cobs or manure-based compost made from stable bedding from local race tracks and horse stables. Both types of compost require the addition of other supplements. The photograph above shows mushrooms in a grading tank, and the photograph at left shows mushrooms being picked.

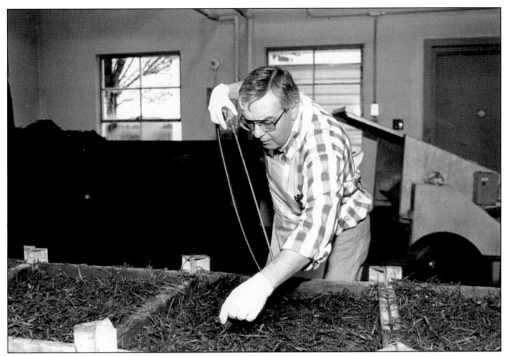

Compost is produced outdoors on a concrete slab, commonly referred to as a composting wharf. The ingredients are thoroughly mixed, wetted, and placed in large piles to initiate the composting process. As the starting materials degrade, the compost continues to be mixed, watered, and supplemented for about 15–25 days. The outdoor process is followed by an indoor pasteurization cycle to kill any pests that are present in the compost. In the photograph above, Dr. Paul Wuest works with the compost. The photograph below is part of the spawn-making process.

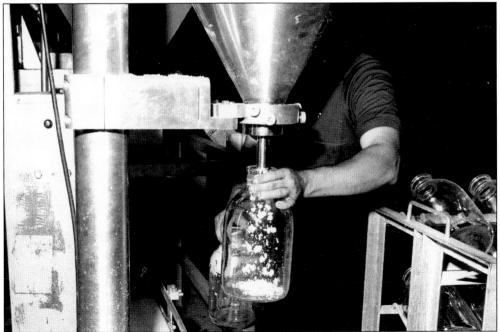

Inside the growing houses, the pasteurized compost is placed in stacked wooden trays or beds, the spawn is mixed in, and a top layer (usually of peat moss) is applied. From this point, it takes about a month to produce the first mushrooms for harvest. Throughout the growing period, temperature and humidity are carefully controlled. On this page are two photographs of signs of mushroom companies.

The Mushroom Capital of the World is made up of a number of independent farms. Many of the farms have been in the same families for generations. Because of the cost of operations and other economic factors, some consolidation is taking place. The photograph above is of a sign at Laurel Valley Farms. The photograph below was taken at Modern Mushrooms.

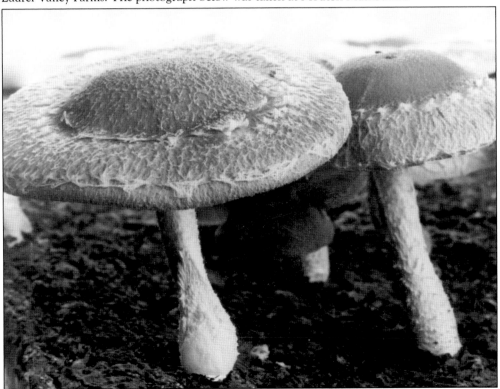

The Kennett Square Mushroom Festival and other events are usually informative and fun for those in attendance. In the photograph above, workers prepare a mushroom bed to be used during a contest. In the photograph below, Stephen Marolin of Wynnwood and his son, Joshua, look over the information on the nutritional benefits of mushrooms.

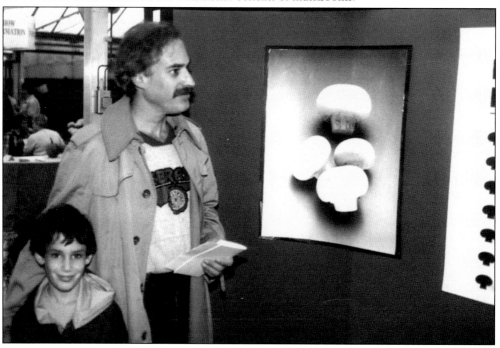

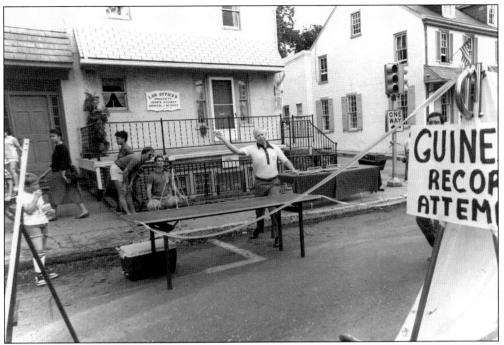

The members of the mushroom industry also usually find a way to have some fun at the events. In the above photograph, Charles Harris, an executive director of the AMI, throws out the first mushroom in a mushroom-throwing contest at the Kennett Square Mushroom Festival. It was a "Guiness record attempt." In the photograph below, which was taken at a Pennsylvania State University event, Lou DiCecco is behind a sign proclaiming the World Mushroom Beach Olympics.

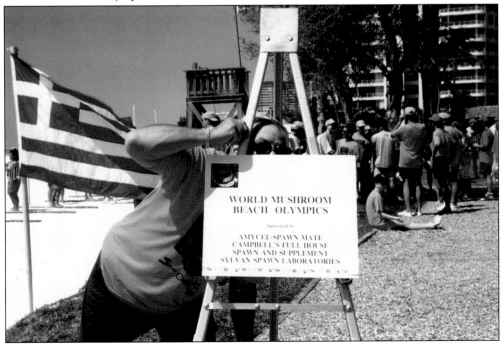

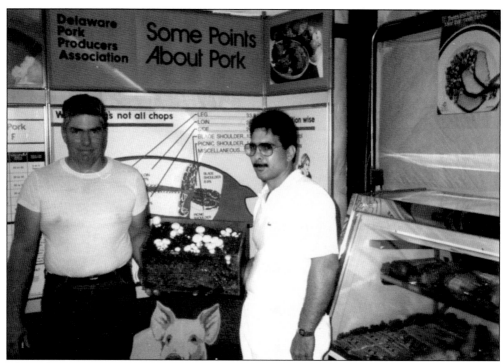

The Delaware Pork Producers Association decided to showcase mushrooms during one of the organization's events. In the photograph above, a case of mushrooms is being held by two men above the head of a pig. In the photograph below, Chris Moyer, who was the AMI's government relations representative, talks about pending legislation that affected the industry.

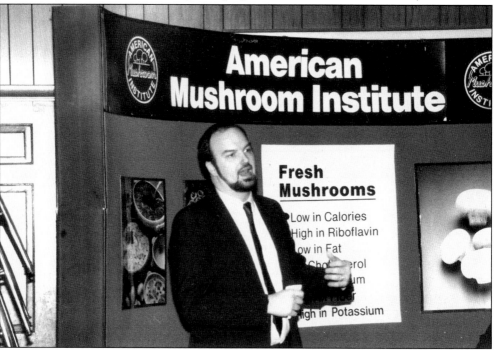

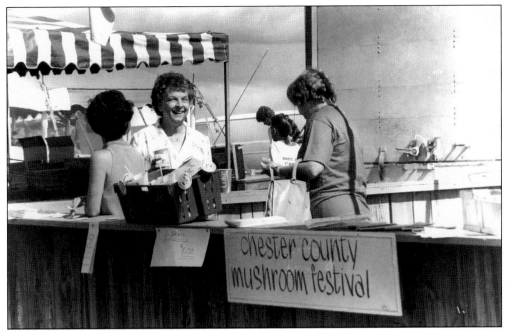

Mushroom promotion events can be formal or informal events. The Chester County Mushroom Festival has more of a carnival atmosphere, as shown in the photograph above. A black-tie event was held in Delaware, as shown in the photograph below. The latter event was sponsored by then governor Michael N. Castle. The designer of the exhibit was Jean Prugh, and the sponsor was Chemical Bank.

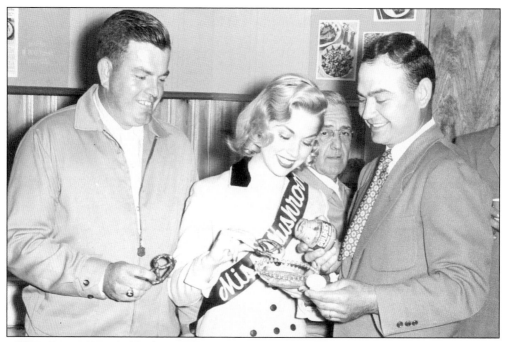

Mushrooms seem to go with just about every type of food. In the photograph above, Miss Mushroom tries another Pennsylvania specialty, salted pretzels. She is dipping a pretzel sample into a bowl of Gulden's mustard. In the photograph at left, two young women at a festival sample mushrooms. Along with the marinated mushrooms are handouts on the nutritional value of mushrooms.

Mushroom companies must guard against all types of disasters. Owners must make sure their crops are disease free. They also must make sure they have enough workers to pick mushrooms at the proper time. There are also safety concerns. As shown by the two photographs on this page, mushroom houses must be protected against fire and other disasters.

Not all of the mushroom shows are done before television cameras. The photograph above has a radio personality sitting in front of his tapes and eating a mushroom. In the photograph below, the 1983 Kennett Square cook-off is shown. Members of the community, the AMI, and a chef gather for a photograph opportunity.

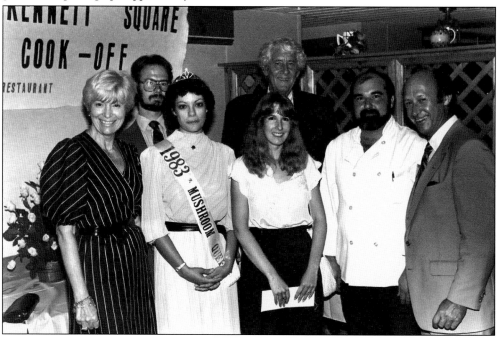

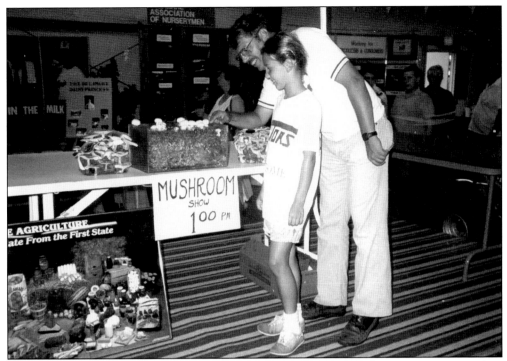

The AMI and the Community Awareness Committee are active in the community, providing college scholarships for deserving students. In the photograph above, a father shows his daughter an aspect of a mushroom display. In the photograph below, Michael Hopkins (center), president of the AMI during 1986 and 1987, receives a contribution. To the right is Jim Roberts, chairman of one of the organization's committees.

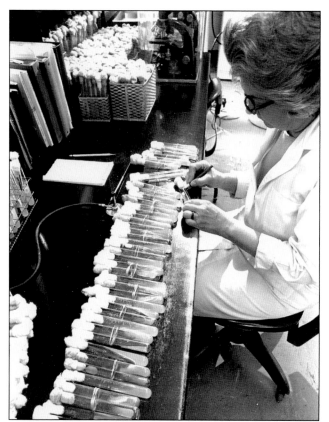

Before a consumer purchases a package of mushrooms in a grocery store, a lot of people perform many different and important jobs. Two of the functions are shown in the photographs on this page. The woman at the left is working on improving the science of mushroom growing. The smiling employee below is standing before boxes waiting to be filled with mushrooms.

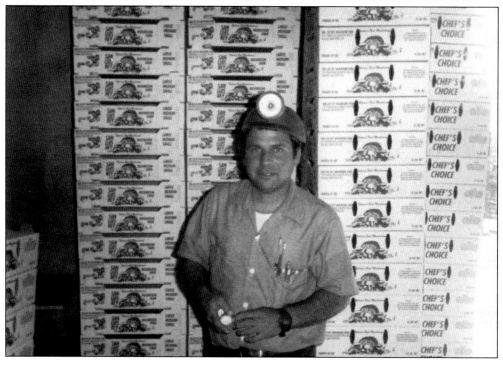

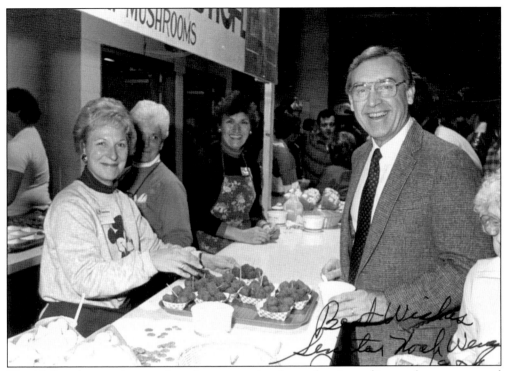

The AMI works to make sure elected representatives know the views of its members on proposed legislation. One of those elected officials, Pennsylvania senator Noah Wenger, is shown in both photographs on this page. Wenger signed the photograph at the top of the page in January 1984. Below, Wenger receives a three-pound basket of white mushrooms from grower Charlie Brosius, who was then chairman of the research committee.

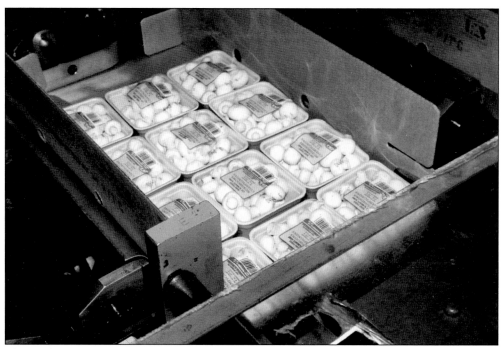

The modernization of the mushroom business makes aspects of the process easier than in past years. The photograph above shows packing machines used by the Moonlight Mushroom Farm of Worthington. In the photograph below, employees scrutinize the packing operations to make sure the mushrooms will be fresh for the consumers.

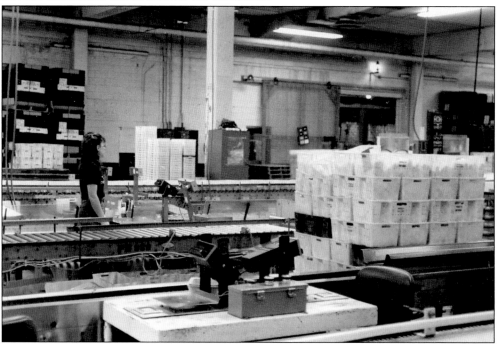

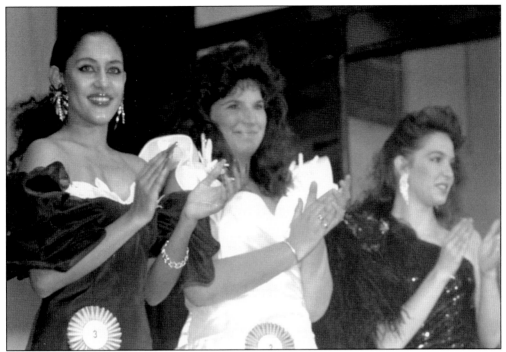

The mushroom industry has been a unifying factor in the Chester County community. Mushroom farming has given different ethnic groups a chance to succeed over the years as the Irish and Quakers were involved early in the industry's development and later Italian and Latino families have owned farms. The photograph above shows contestants in a mushroom festival promotion. The photograph below is a 1940 view of the John Camorando farm in Toughkenamon, Chester County.

Those in the mushroom industry have a sense of humor, as shown by the photographs on this page and other photographs in this book. A mushroom mascot is shown at the top of the page. The photograph below shows a man wearing a shirt that says, "You can tell a plant pathologist but you can't tell him much."

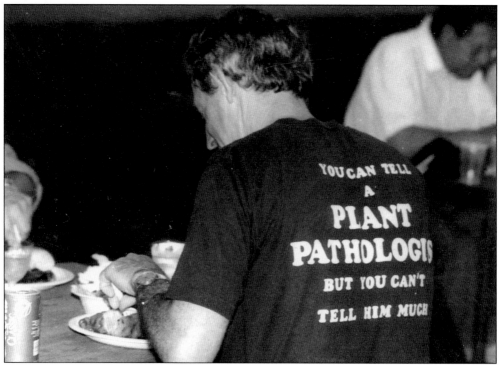

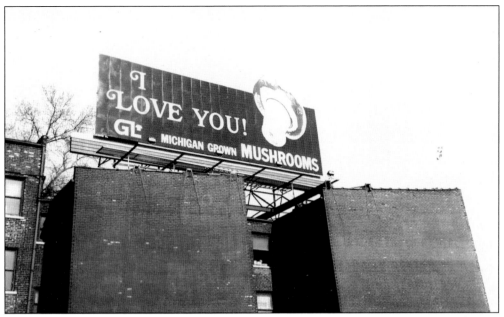

The title of this book is *Chester County Mushroom Farming*. Chester County is the Mushroom Capital of the World, but mushrooms are an international treasure, as the photographs on this page show. The photograph above is an "I love you!" mushroom sign in Michigan while the photograph below is a welcome sign for the North American Mushroom Conference. The cochairman for the AMI was Chester County's Charles Ciarrocchi.

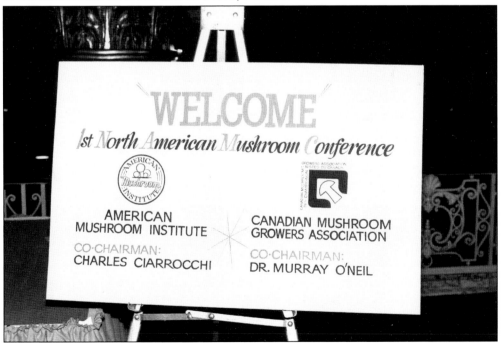

ACROSS AMERICA, PEOPLE ARE DISCOVERING SOMETHING WONDERFUL. *THEIR HERITAGE.*

Arcadia Publishing is the leading local history publisher in the United States. With more than 3,000 titles in print and hundreds of new titles released every year, Arcadia has extensive specialized experience chronicling the history of communities and celebrating America's hidden stories, bringing to life the people, places, and events from the past. To discover the history of other communities across the nation, please visit:

www.arcadiapublishing.com

Customized search tools allow you to find regional history books about the town where you grew up, the cities where your friends and family live, the town where your parents met, or even that retirement spot you've been dreaming about.